And you know what:
That was a design decision.
Yes, indeed.
Whether you realize it or not,
most of the decisions
you make,
every day,
are by design.

What do I mean
by this?

**That's a very good question, and what
we'll be exploring in this book, but in the
meantime, take my word for it . . .**

... you are a designer. Ready?

CHIP KIDD, AGE 5, 1969.
KINDERGARTEN SCHOOL PHOTO,
LINCOLN PARK ELEMENTARY, PA.
The use of such images by graphic
designers in their books is,
admittedly, a shameless way to
gain immediate sympathy from
readers. It's also very effective.

GO

A KIDD'S GUIDE TO GRAPHIC DESIGN

Chip Kidd*

WORKMAN PUBLISHING

NEW YORK

*Yes, that's my real name. Sort of. Okay, it's Charles, but that doesn't sound nearly as interesting, and besides, the nickname was my mother's idea in the first place, when I was still a zygote. Remember, your name is a BIG part of . . .

the
design
of
YOU.

But let's not get ahead of ourselves. There is a LOT to learn before we get to that, and first we have to deal with the copyright page. This is very important, because copyright is a way to protect original ideas. Why do ideas need protecting? Because, like unlocked bicycles, they can be stolen pretty easily. And if that happens, you need an official record of when and where your ideas first appeared in order to stake your claim to them (like a cell phone pic of your bike the last time you saw it). So that's what this is for. The symbol for copyright is a letter *c* with a circle around it. Like this:

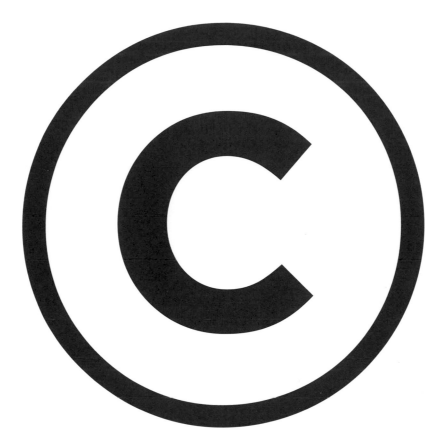

It is not clear exactly who designed it, but it was first submitted in 1906 by Herbert Putnam, the Librarian of Congress, as part of a bill that would eventually be passed into law as the The United States Copyright Act of 1909. One of the great things about this symbol, in addition to its simplicity, is that it is easily readable when it is teeny tiny. Like this:

For Raquel Jaramillo, without whom this book wouldn't exist. And heartfelt thanks to Krestyna Lypen, Geoff and Jet Spear, J. D. McClatchy, Charlie Kochman, and of course Amanda Urban.

Ⓒ O N T ' D

Library of Congress Cataloging-in-Publication Data is available.

ISBN 978-0-7611-7219-2

Design by Chip Kidd
Photographs by Geoff Spear

Workman books are available at special discounts when purchased in bulk for premiums and sales promotions as well as for fund-raising or educational use. Special editions or book excerpts can also be created to specification. For details, contact the Special Sales Director at the address below, or send an email to specialmarkets@workman.com.

Workman Publishing Company, Inc.
225 Varick Street
New York, NY 10014-4381

workman.com

WORKMAN is a registered trademark of Workman Publishing Co., Inc.

Printed in China
First printing September 2013

10 9 8 7 6 5 4 3 2

CONTENTS

OKAY, SO JUST WHAT *IS* GRAPHIC DESIGN?

The dull but correct answer is that graphic design is purposeful planning that uses any combination of forms, pictures, words, and meanings to achieve one's goal.

But that is boring.

The far more interesting answer is that graphic design is problem-solving (and sometimes making something really cool in the process). There are all kinds of problems to solve: good, bad, complicated, easy, annoying, fascinating, dull, life-threatening, mundane. There are problems that matter only to you and no one else, and problems that determine the fate of mankind. And some of them are truly unsolvable—but of course that doesn't stop people from trying, and it shouldn't. But the main thing to learn about graphic design problem-solving is that the best solution can usually be found in the best definition of the problem itself. I know that sounds contradictory and weird, but it's true. We'll come back to that in Chapter 3.

EVERYTHING NEEDS TO BE DESIGNED.

Because there's so much stuff everywhere, we tend to take for granted that someone has to make it all. It isn't until you try to create some of it yourself that you start to appreciate the thought and the effort that it can take to design things.

Often the best design solutions are born out of necessity. Sometimes you design something not because it's fashionable, cool, or even profitable, but because it's something that you need to fix a problem you have.

The speed bump. Yes, the speed bump.

In 1953, Arthur Holly Compton, a Nobel Prize–winning physicist, became concerned about people driving their cars too fast past Brookings Hall, where he was a chancellor at the University of St. Louis in Missouri. So, he created one of the most effective, practical designs of the twentieth century: A simple squashed "log" of asphalt laid across the road provided the perfect little jolt to keep people from accelerating their cars down residential streets. The speed bump solved the problem quickly and economically, forcing drivers to obey the speed limit. However, for the purposes of this book, it's important to note here that while the speed bump is brilliant design, it is not graphic design. This is graphic design.———→

SPEED BUMP AHEAD

That's an important lesson: Drivers can ignore the sign, but they can't ignore the bump itself. Does that mean the sign is not important? No, because if you pay attention to it, then you won't have your coffee spilled in your lap. The point is that graphic design works differently than other kinds of design.

AND HOW IS THAT?

Graphic design needs your willing mental participation, even if it's subconscious. Graphic design is message-sending into the brain. It is a cerebral experience, not a physical one. Architecture wants you to walk through it. Industrial design takes your hands (or other body parts) to appreciate it. Fashion makes you put it on.

BUT GRAPHIC DESIGN IS PURELY A HEAD TRIP, FROM YOUR EYES TO YOUR MIND.

HOW DOES IT DO THAT?

Through visual and typographic components that, when put in the right combinations, can literally get you to start or stop doing something. That's pretty remarkable.

One of the most obvious and common examples of this is the good old red circle with a diagonal red slash across it, a white background, and an image inside it (usually in black) of whatever you're not supposed to be doing, using, saying, or possessing. I don't even have to show it here—you're picturing it in your head right now.

WHY SHOULD YOU CARE?

BECAUSE IT AFFECTS YOU ALL THE TIME.

On average, every person in America is exposed to thousands of images a day, whether through advertising, television, the Internet, packaging, other people's tattoos, or T-shirts. On the next two pages, you'll see a sampling of a bunch of things an average kid might see on any given day, starting from the moment they get up in the morning to the moment they go to sleep at night. Every single one of those things was designed by someone, a person whose job it was to decide what color it should be, where to put the type, what font to use, and how it should look. Whether it's the fine print on the back of a shampoo bottle, the colors on a box of cereal, or where to put the numbers on your remote control, there's a great deal of thinking that goes into the things you use, read, purchase, play with, and consume.

EVERYTHING THAT IS *NOT* MADE BY NATURE IS DESIGNED BY SOMEONE.

Graphic designers design the labels and branding on every product in your house, from the shampoo bottle you keep in the bathroom to the cartons, bottles, and cans stored in your refrigerator.

Notice the oval-shaped label? It's reminiscent of a drop of water. You think that's a coincidence? No! A designer thought to do that.

This carton of milk evokes the pattern on a cow. Here's an example of a designer drawing inspiration from nature.

A designer had to decide on the size of the fine print being used in the Nutrition Facts portions of this soda can and juice box. Remember, you need to be able to read fine print, but it's not meant to be as important as the rest of the stuff on the container.

The style of the typeface is an important design choice, as is the color.

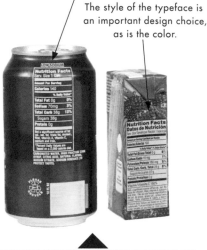

It's not just the front of food packaging that's designed: Every single thing on those products needs to be designed—including the backs of the boxes!

Ever notice the small stuff? Someone decided where that tidbit of information should go!

All the information that comes on or inside your board games and sports equipment is designed by someone. The logo on your Xbox? Those LEGO® instructions? They were all designed by someone!

Red is a color that always seems to say "notice me!"

Personally, I find TV remote controls to be horribly designed because they're so complicated to figure out.

Nice mix of script and sans-serif type on this softball!

This tic-tac-toe game is made up of primary colors: red, yellow, and blue (see pages 62–63).

A remote control's numbers and letters have to be easy to read. Colors are used to differentiate the most frequently used buttons. Red was used for the two buttons that are the most important.

The interiors of books are designed—just like book covers are. A book designer chose the text font for this book, for instance, and the size of the font, which then determined how many pages long the book would be.

I love the bold red letters on this notebook cover!

NOTES

Notice how the font used for the chapter title is different than the text font?

Even the page numbers are designed!

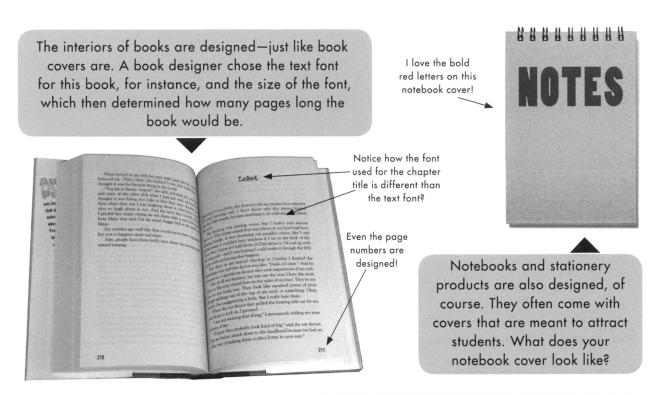

Notebooks and stationery products are also designed, of course. They often come with covers that are meant to attract students. What does your notebook cover look like?

Not everything that's designed needs to be typeset. Design choices are made every day by people who do the lettering for handmade signs in front of stores, like this one.

This street sign has to be legible from far away, in good weather or bad. Someone had to make the design decision to use white type on a red background. A lot of traffic signs are red. Can you think of why?

On this sign, some words are written in all caps, and some are upper- and lowercase (see pages 88–89). Can you spot the spelling mistake, by the way?

NO STANDING
EXCEPT TRUCKS
LOADING & UNLOADING
10AM - 4PM
EXCEPT SUNDAY

SP-2568 DEPT. OF TRANSPORTATION

WOMEN'S
+ GIRLS
CLOTHING
+ ACCESORIES
❀ Clean
❀ Pre-owned
❀ Stylish

Some of the words on this sign are bigger than the others. The size of the type helps emphasize the most important part of the message.

Multiply everything on the previous two pages by however many days old you are, and it adds up to a LOT of information. Learning the thinking behind how those images are made will help you figure out why the visual world works the way it does, and how you can be part of creating it.

Or at least, avoid being too manipulated by it.

Even if you don't want to become a graphic designer, it doesn't hurt to know what its components are and how they work. To do that, you have to learn the rules of graphic design. Because once you do that, then you can learn how to effectively break them, and *that's* where the real fun begins.

But wait a minute.

WHO AM I, AND WHY SHOULD YOU BELIEVE ANYTHING I SAY?

I ask myself this all the time, believe me. As I write this, I have been a working graphic designer for over 26 years, and don't intend to stop anytime soon. Most of my work is for covers of adult books. I haven't done too many kids' books, but I've done a lot of other kinds of projects, including graphic novels and comics. And I've written a couple of novels, too. Overall, I think I've done over 1,000 book covers to date. That fact alone, of course, doesn't necessarily prove that any of them are any good. I'm putting a bunch of samples of my covers on the next few pages. Through the rest of this book, I'll be using examples of my work to illustrate various concepts, though I'll be showing other people's work, too.

On the opposite page is the cover I designed for *Jurassic Park* by Michael Crichton (see sidebar), which is probably one of the most recognizable covers I've ever designed. Even if you're not familiar with the book, the design might feel familiar to you because it was used for the movie poster.

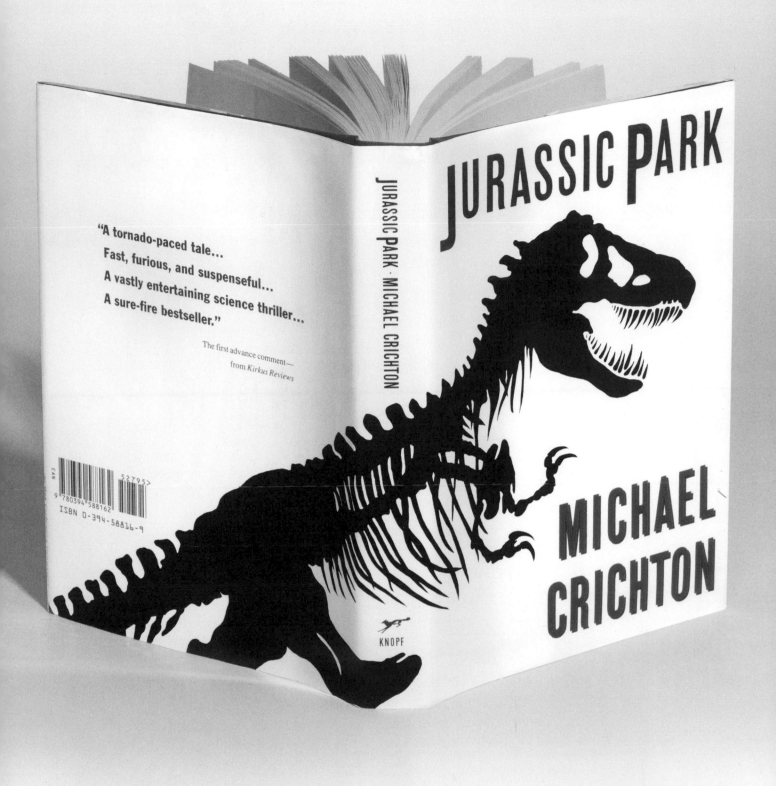

JURASSIC PARK

JURASSIC PARK · MICHAEL CRICHTON

"A tornado-paced tale...
Fast, furious, and suspenseful...
A vastly entertaining science thriller...
A sure-fire bestseller."

The first advance comment—
from *Kirkus Reviews*

MICHAEL CRICHTON

KNOPF

EAN

9 780394 588162

527957

ISBN 0-394-58816-9

MICHAEL CRICHTON (1942–2008) was a visionary author of popular novels, specializing in science fiction, much of it based on real technology. He is probably most famous for writing *Jurassic Park*, the cover for which I was privileged to illustrate and design (above). The drawing I did of the partially-filled-in T-rex skeleton was optioned by Universal Studios to become the symbol of the movie, and went on to become one of the most recognizable images of the 1990s. I designed five more books for him: *Rising Sun*, *Disclosure*, *The Lost World*, *Airframe*, and *Timeline*. I enjoyed working with him a lot, and will never forget that I first learned about "email" when I was reading the manuscript of *Disclosure* in 1993. I thought "Yeah, right. Like *that's* gonna happen."

A BRIEF TOUR THROUGH THE HISTORY OF GRAPHIC DESIGN

Even though it dates back to 15,000 B.C., graphic design as we know it today is a relatively recent phenomenon—it wasn't even called that until 1922. But the elements of visual communication, or using words and pictures to express ideas, have been around through the centuries. Graphic design really picked up steam at the end of the 1800s, thanks to the Industrial Revolution, a time when new manufacturing processes made mass-production possible.

If you want to be a great graphic designer, you have to know what's been done, when it happened, who did it, and why. Not only is learning the history of graphic design fascinating but it will help you to develop ideas of your own. It will help you look at the world differently, which is what I'll be asking you to do in this book. On the next seven pages is an extremely brief look at some of graphic design's historical highlights. There are a LOT more examples, but this is just to get you started.

15,000–10,000 B.C. *Cave paintings at Lascaux, France.* The first record of man's creativity, these beautiful pictures were painted using mineral pigments by our cave-dwelling ancestors in Paleolithic times.

3300 B.C. *Egyptian hieroglyphics.* The early writing system, a mix of figurative and symbolic pictures representing real things, wasn't fully deciphered until the 1820s.

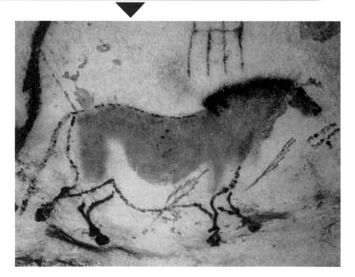

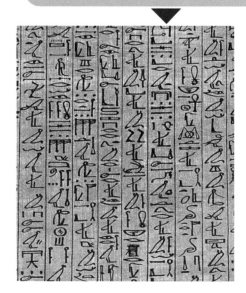

8th and early 9th centuries *The Book of Kells.* One of the most beautiful illuminated manuscripts ever, *The Book of Kells* was created by Celtic monks, who spent years of their lives meticulously hand-lettering the Gospel, decorating the pages with silver and gold accents, and drawing elaborate miniature illustrations to accompany the text.

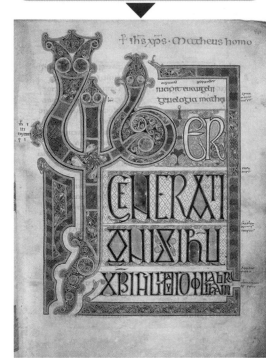

1450s *The Gutenberg Bible.* The first major work of literature to be printed on a movable-type printing press, this bible is named for the inventor, Johannes Gutenberg. By creating a machine that would allow for multiple editions of a book to be made at the same time, Gutenberg revolutionized how people obtained information—not to mention how the words looked on the page.

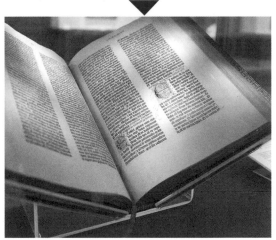

1530 *The Garamond font.* As printing presses came into popular use, more fonts were needed by printers and publishers. Claude Garamond opened the first type foundry, a workshop devoted to developing and selling fonts to printers. The Garamond font remains popular to this day.

1777 *American flag.* It might not have been the very first American flag design, but the Betsy Ross version is the one that became the basis of our current American flag. It's a great example of the use of horizontal stripes in a design (see pages 44–45).

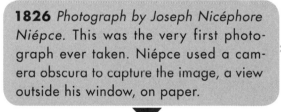

1776 *The Declaration of Independence.* One of the riskiest feats of visual and verbal expression in American history. All of the signers risked being executed

1826 *Photograph by Joseph Nicéphore Niépce.* This was the very first photograph ever taken. Niépce used a camera obscura to capture the image, a view outside his window, on paper.

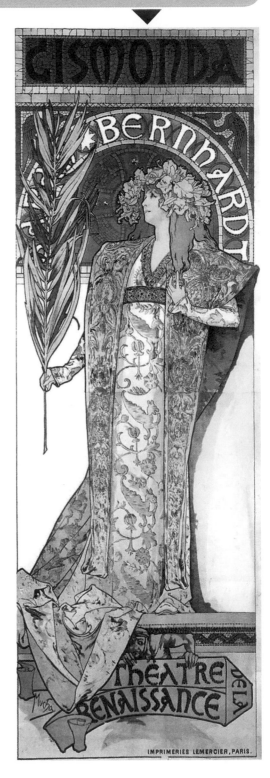

1890 *Poster by Alphonse Mucha.* The Art Nouveau movement in France began as a way of combining art and design in a new, decorative way. Typography and letters were often painted directly into the art, which is something that hadn't been done since the days of illuminated manuscripts (see page 13). The Art Nouveau movement paved the way for Modernism two decades later.

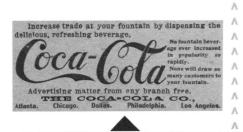

1886 *Logo for Coca-Cola.* Rumored to have been designed by the company founder John S. Pemberton, this logo hasn't changed much at all since then, as seen in this coupon ad from 1900.

1919 *Poster by Alexander Rodchenko.* Artists yearning for a bold, new graphic language found it in Russian Constructivism, a movement that sought to use art as a way of advancing political and social causes.

1919 *Poster for the Bauhaus School of Design.* This school, which opened in Weimar, Germany, embraced all of the design disciplines, including crafts, architecture, painting, and typography. It ushered in a new era of simplicity in graphic design.

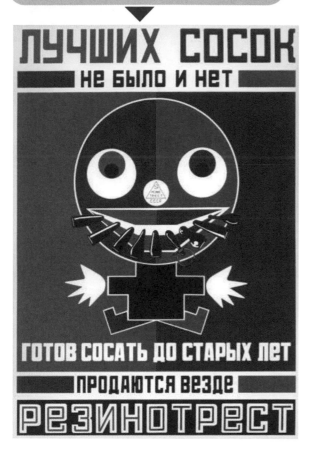

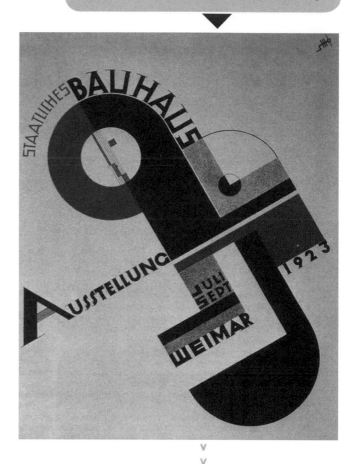

1922 *Book design for* The Time Machine *by W. A. Dwiggins.* A well-known designer in his day, Dwiggins may have made his greatest contribution to the world of graphic design by coining the term "Graphic Design."

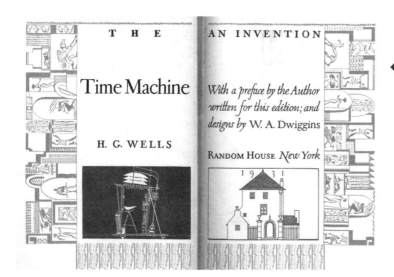

> > > > > > >

1957 *Helvetica font.* Max Miedinger designed the Neue Haas Grotesk font, later renamed Helvetica, one of the most-used typefaces of all time.

1959 *Colorforms logo.* Paul Rand's clever, simple geometric logo for the Colorforms brand brought the simplicity of the Bauhaus (see opposite page) to a mass audience of kids.

1967 *Bob Dylan poster by Milton Glaser.* Glaser's iconic design became emblematic of the "psychedelic" design of the '60s, as did many of the poster and magazine designs that came out of Glaser's studio, Push Pin Studios.

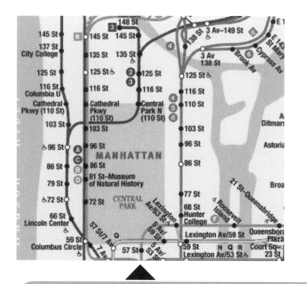

1972 *New York City subway map.* As NYC's subway system kept growing, finding a way to design a map so that it was all easily understood was no easy feat, but Massimo Vignelli's brilliant simplification and labeling system proved to be a highly effective and enduring solution to the challenge.

1984 *The first Apple computer.* Although it didn't do too much by today's standards, the first Apple computer, created by Steve Jobs and Steve Wozniak, started a revolution in how ordinary people interface with machines. Although other computers existed at the time, the Apple was the first to be user-friendly, with a design and format specifically created for consumers who were not already computer-savvy: that is to say, mostly everyone.

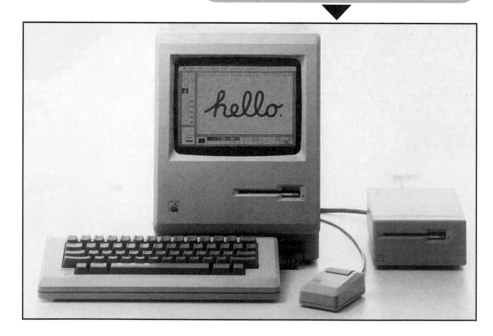

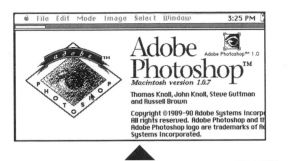

1989 *Adobe Photoshop version 1.* When this software product was first released, it gave people the ability to tinker with photographs in a way that had never been an option before without technical training and photographic experience. No image will be completely trusted again.

1990 *The World Wide Web.* British computer scientist Tim Berners-Lee developed the World Wide Web, along with HTML, HTTP, and the concept of website addresses.

2007 *Barack Obama "O" logo designed by Chicago-based firm Sender LLC.* This iconic logo, with its brilliant use of negative space (see how the inside of the *O* is a sun on the horizon), became known throughout the country as a symbol of hope and change. "Yes, we can!"

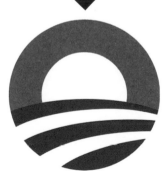

What will come next? Maybe your design?

Your work here.

CHAPTER 1

BIG AND SMALL

SCALE

TOP TO BOTTOM / INVERSION

LEFT TO RIGHT

IN FRONT OF / IN BACK OF

FOCUS / OUT OF FOCUS / JUXTAPOSITION

VERTICAL

HORIZONTAL

LIGHT / DARK

IMAGE QUALITY

IMAGE CROPPING

REPETITION AND PATTERN

SYMMETRY / ASYMMETRY

SIMPLICITY / COMPLEXITY

COLOR THEORY

PRIMARY COLORS/ SECONDARY COLORS

ABSTRACT / LITERAL

POSITIVE SPACE / NEGATIVE SPACE

VISUAL VARIATION

The first component of graphic design we're going to explore is *form*. Form is simply what things look like. When you are a tiny baby, you perceive things you see only as forms because you don't yet know how else to do it. You take in shapes, colors, levels of intensity, sizes, but not meaning. A good graphic designer needs to learn how to revert to this state in order to evaluate visual information and make effective design decisions.

This does not mean that you have to think like a tiny baby, but it would be great if you could relearn how to *see* like one. An interesting way to do it is to look at graphic design that you cannot read. If you don't understand Japanese, you can perceive the images below and on the opposite page only in terms of what they look like. This frees you up from processing what they are trying to say and lets you just consider the arrangement of the elements. Not that what they say is not important (below is about an oil company, opposite is for a boat race), but when you start to learn to make graphic design, it helps to understand first how things look, because that will be the last thing to consider.

and

SMALL

The concept of "big and small" in graphic design may seem very simple, but it doesn't have to be, and it is almost always more interesting when it's not (see above). In fact, "big and small" on the page or screen is all about ratio and not really about size. Ratio is the comparison of one object or group to another (see Scale, page 32). You consider ratios all the time, automatically, even if you aren't good at math. For example, if it's a particularly rainy day and there's a large puddle in the middle of your walkway, you have to consider if you can jump it or not. You weigh multiple factors into this, such as your ability to jump, the size of the puddle relative to your stride, what you are wearing (how much do you care if you get it wet?). You might also consider the slickness of the surface on the other side, and a whole bunch of other stuff, depending on your situation.

In a graphic design problem, you're doing the same thing: You're determining how far you can take things and still land successfully.

Here is a very cool, simple design trick:

If a piece of visual information looks interesting when it is small,

then it will look even more so when . . .

And then make it small again.

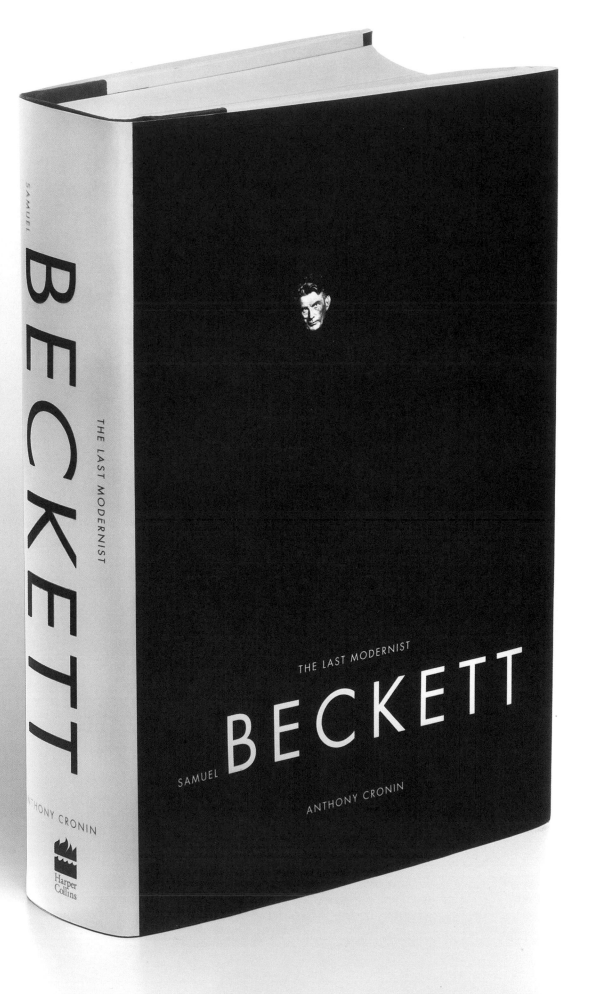

I used this "big and small" trick on a jacket I designed for a book about the famous Irish writer and playwright Samuel Beckett (opposite page).

When you design book covers, you often have to learn a lot about the subject of the book. If it's a work of fiction, you need to read the book to figure out what themes you could use to best illustrate the story. When it's a work of nonfiction, like this biography about Beckett, you have to become familiar with the writer's work. I found that Beckett's plays, while truly brilliant, were often really, really weird. One of them featured just a disembodied head, brightly lit, while the rest of the stage was stark black. When I read that play, I thought it would be the perfect way for me to depict Beckett on the front cover of this book. Using Beckett's head really small on the cover was a way to mirror one of his plays while also using the design concept of "big and small" to maximum effect.

Every part of a book is designed, by the way. Notice the spine of the book has a white background, and not a black one like the front. That was a design choice. Do you see the part of the book that's inside the book jacket? Part of it is black and the other part is white. A person whose job it is to design the interior of the book made that design choice based on the book cover. Did you know even the interior of the book is designed? The fonts that are used, the size of the font, how big the margins on the page are, where the folios (those little numbers on the bottom of the page that tell you what page you're on) or the running heads (the small words that tell you what chapter you're in) go—all of that stuff is designed. Even the type of paper being used is a design choice!

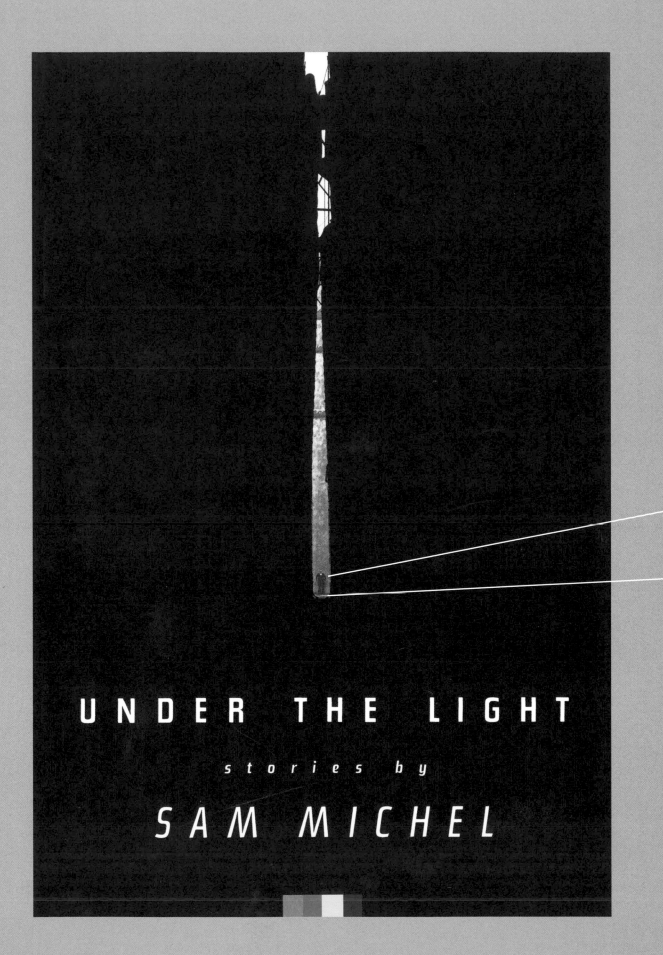

UNDER THE LIGHT

stories by

SAM MICHEL

I also used the concept of "big and small" for a book of short stories by Sam Michel called *Under the Light* (opposite page). I used a photograph by Harry Callahan (see sidebar) that features the figure of the man completely dwarfed in relationship to his surroundings. He is in a spotlight of his own circumstances. I thought it went really well with the title of the book and the themes of the short stories.

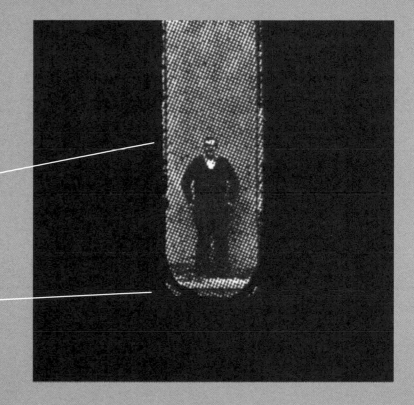

HARRY MOREY CALLAHAN (1912–1999), a very influential American photographer, began teaching himself photography in 1938 at the age of 26. It wasn't until 1941, however, after hearing a talk Ansel Adams (a master of western landscape photography) gave about photography, that Callahan started to take his own work seriously enough to pursue a career in photography. In 1946 he was invited to teach photography at the Institute of Design in Chicago. He moved to Rhode Island in 1961 to establish a photography program at the Rhode Island School of Design, teaching there until his retirement in 1977. When he died, there were more than 100,000 negatives in his collection: an incredible body of work to leave behind.

SCALE

Scale is an extension of the function of "big and small." It's a very effective graphic tool, and you just saw a prime example of it on the previous pages.

I have found that the more extreme you can use scale, the better it works. That is, if the bigs are bigger and the smalls are smaller, when paired next to each other, the result can be very dramatic.

On the opposite page is the design I did for the cover of the great Batman story by Frank Miller, *The Dark Knight Returns*, published in 1986. All of the art had already appeared in various comics over the years, so I gave the components a visual hierarchy, or order of visual importance. Batman dominates, as would be expected, but he is not how you're used to seeing him, a figure of great mystery. The other players in the story loom beneath, obstacles to be dealt with, commanded, challenged, or defeated: Bruce Wayne, Superman, The Joker, Commissioner Gordon, Selina Kyle, a kidnapped child, and Alfred the faithful butler. But they are small compared to Batman. The scale is what makes this cover work especially well in a comic book store, among other covers that tend to be very busy. The horizontal yellow band of color refers to Batman's utility belt. The large black expanse on this acts as a visual anchor.

BATMAN: A GREAT AMERICAN DESIGN. Created in 1939 by artist Bob Kane and writer Bill Finger, The Bat-Man (as he was originally called) was intended to darkly complement the bright optimism of Superman, DC Comics's most popular superhero. It took them a full year of monthly stories in *Detective Comics* to figure out who the character actually was. At first he used a gun, and would dispatch his enemies to death if that's what it took to stop them. All that changed in 1940, when they first explained his origin: Bruce Wayne's parents were gunned down in front of him as a child. Once that was established, Batman's sacred rule of no guns and no killing was set in stone, and hundreds of writers and artists have been building on it ever since, in every imaginable medium. I think one of the main things that has kept him so popular is that he is a great American idea: You can have everything, have it all taken away, and then have to start all over again. You have to reinvent yourself. All you need is the will, determination, and a great sense of design.

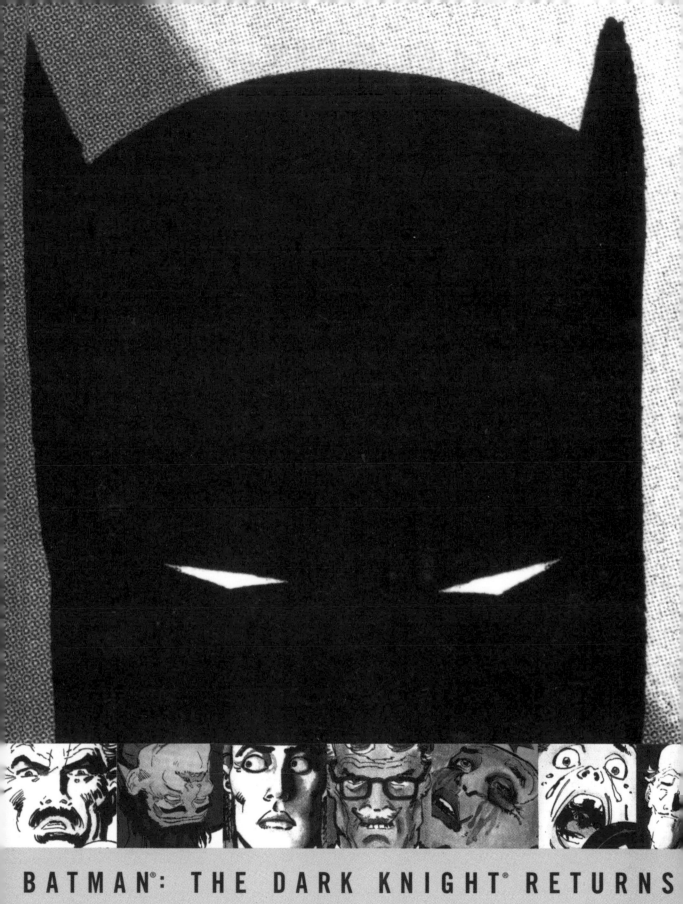

BATMAN®: THE DARK KNIGHT® RETURNS

FRANK MILLER

with KLAUS JANSON and LYNN VARLEY

In most cultures, visual messages are perceived from top to bottom: Our eyes start at the top of a page and work their way down. You know where the viewer is going to begin looking at something, so if you have very important information, you put it at the top. This cover for my Batman graphic novel turns this visual trickery upside down—literally.

INVERSION

A

H A N D B O O K

F O R

D R O W N I N G

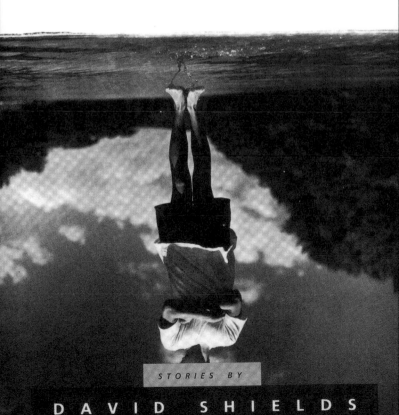

STORIES BY

D A V I D S H I E L D S

LEFT TO RIGHT

In the Western world, text flows from left to right, and the order in which objects are perceived follows suit. This directs how the eye tracks visual information on a page or screen, which means that if you want to give something greater importance, you put it on the left. The book cover on the opposite page, by designer Peter Mendelsund, for a collection of short stories called *Things We Didn't See Coming*, very cleverly exploits this idea. He shifts the "window" on the title about a quarter of the way to the left in order to make a visual game out of what the title is saying, based on *what* it's saying.

Think about it. You can't read the title from left to right: You actually have to go back and forth, right to left, to piece the title together. What more perfect way to illustrate the title than showing an example of "things we didn't see coming"? Very clever, Mr. Mendelsund!

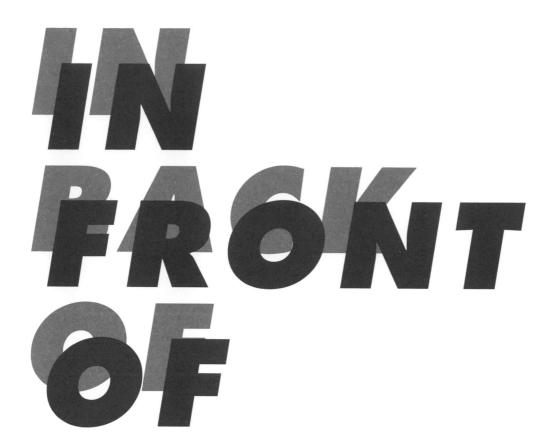

IN BACK FRONT OF OF

When something is in front of or in back of something else, it's an illusion. Why? Because even though we can't see something, we know it's there. Magicians use this concept all the time, and viewers of magic tricks always want to know: What's behind the curtain? What's inside the hat? Using this illusion in graphic design is a way of visually stimulating the same curiosity.

For the cover of Robert Hughes's account of the history of modern art, I made it look like someone had taken a rather plain white book with plain black type and slapped a glossy superbright sticker on it. Although everything is actually on the same two-dimensional plane, it looks like the sticker is "on top" of the book. In painting, this effect is known as *trompe l'oeil*, or "trick of the eye." Painters, like designers and magicians, know a good trick when they see one.

ROBERT HUGHES (1938–2012) was described by the *New York Times* as "The most famous art critic in the world." He was also one of the most influential. You might think that made him difficult to design books for, but he was actually really great. Even when I made an embarrassing grammatical mistake on the cover to the right. Can you find it?

THE

SHOCK

OF

THE HUNDRED-YEAR HISTORY OF MODERN ART—

IT'S RISE, ITS DAZZLINC ACHIEVEMENT, ITS FALL

ROBERT HUGHES

FOCUS

JUXTAP

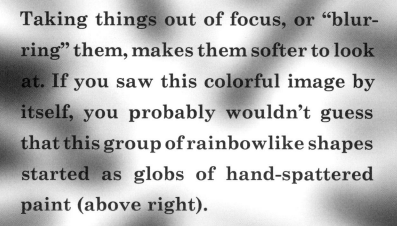

Taking things out of focus, or "blur-ring" them, makes them softer to look at. If you saw this colorful image by itself, you probably wouldn't guess that this group of rainbowlike shapes started as globs of hand-spattered paint (above right).

OSITION

When you put something that's in focus together with something blurry on the same page, it makes a visual contrast, or something called a "juxtaposition." This is a visual comparison of one thing to another, often two very different things that make a new idea when combined.

OUT OF FOCUS

VERTICAL

Vertical lines emphasize height and sturdiness. Use them when you want to imply a sense of elegant stability, as on wallpaper.

TRUE PREP

IT'S A WHOLE NEW OLD WORLD.

by the author of
THE OFFICIAL PREPPY HANDBOOK
LISA BIRNBACH
with Chip Kidd

HORIZONTAL

Horizontal lines emphasize layers and width, and the strength those provide. The cover on the right, which was designed by Katy Finch, is a good example of how horizontal lines can be used to convey a serious subject with as little drama as possible.

The Boy
in the
Striped
Pajamas

JOHN BOYNE

LIGHT

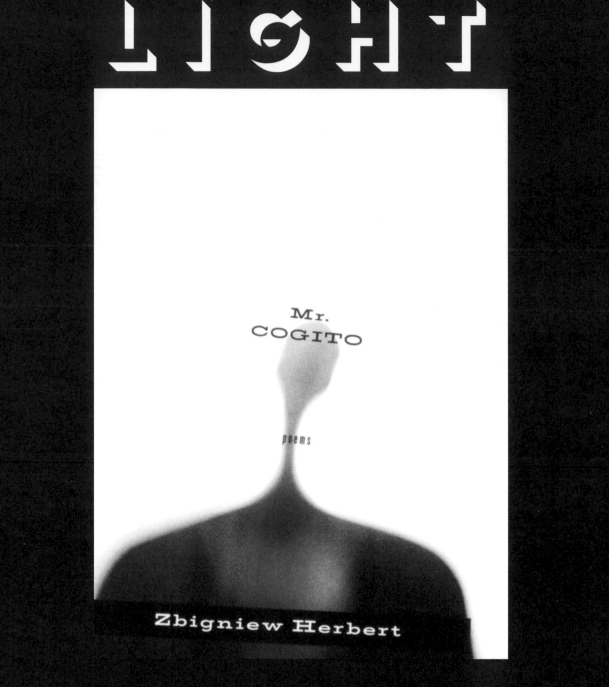

Mr. COGITO

poems

Zbigniew Herbert

This book by Polish poet Zbigniew Herbert is about the everyday life of an ordinary man, or, as he is called in literature, The Everyman. So he could be anyone. That's why I chose to represent him with a blurred image. You can imagine for yourself what he looks like. But the tone of the writing is very light, and that's why the background is white. As opposed to . . .

DARK

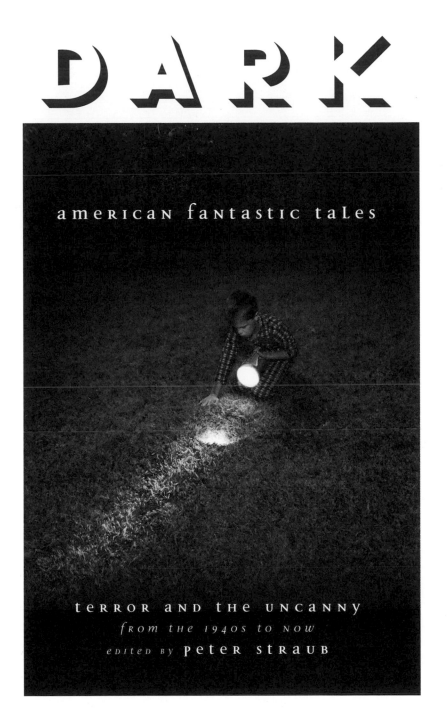

american fantastic tales

terror and the uncanny
from the 1940s to now
edited by peter straub

. . . this collection of scary stories, in which the photo by Frederik Broden eerily captures the night and its mysteries. The brightness of the flashlight in the boy's hand and the glow of whatever's about to emerge from the hole in the ground are almost overwhelmed by the darkness around them. It's a very suspenseful image, one that makes you think: What's going to happen next?

IMAGE QUALITY

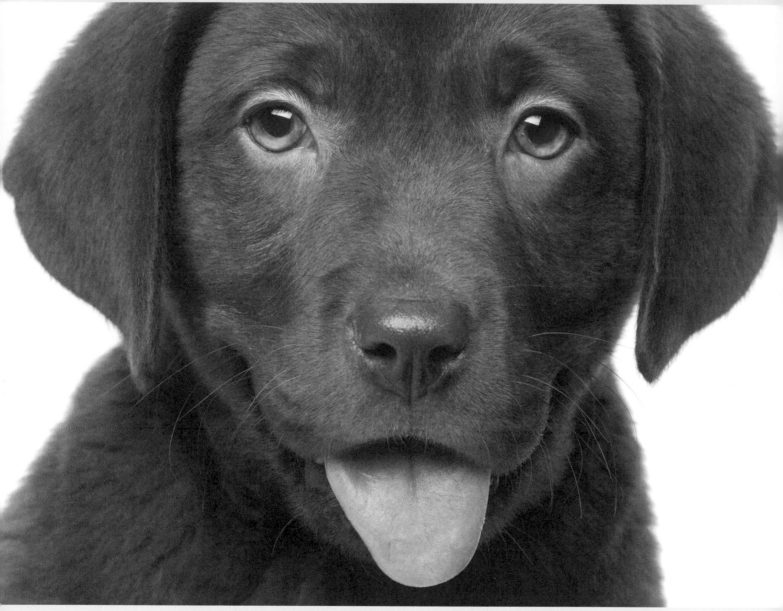

300 DPI:GOOD.

Image quality is not quite the same as in-focus or blurry, it's actually a technical thing. Digital images are composed of "dots per inch," or DPI. If you want good quality for printing, the standard count for a nice clear image is 300 DPI or above. Let's see what happens when we go below that number. . . .

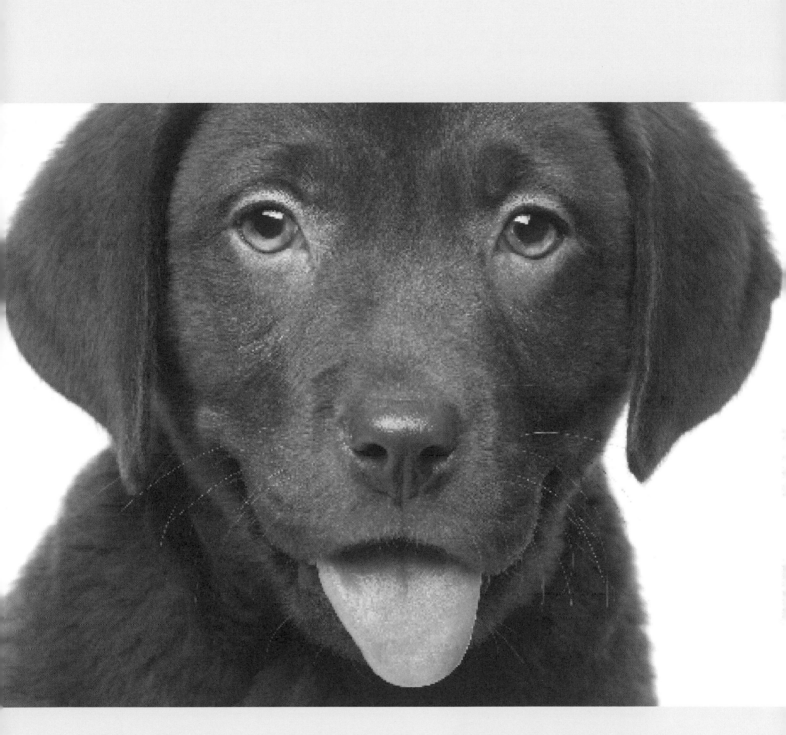

72 DPI: OKAY FOR WEB, BAD FOR PRINT.

The weird thing about 72 DPI is that it looks fine on your computer screen, but when you go to print it out, it starts to look blocky, or "bit-mapped." Do you see how the puppy's whiskers are a little jagged now? The less DPI you have, the more blocky the image is going to get. As in . . .

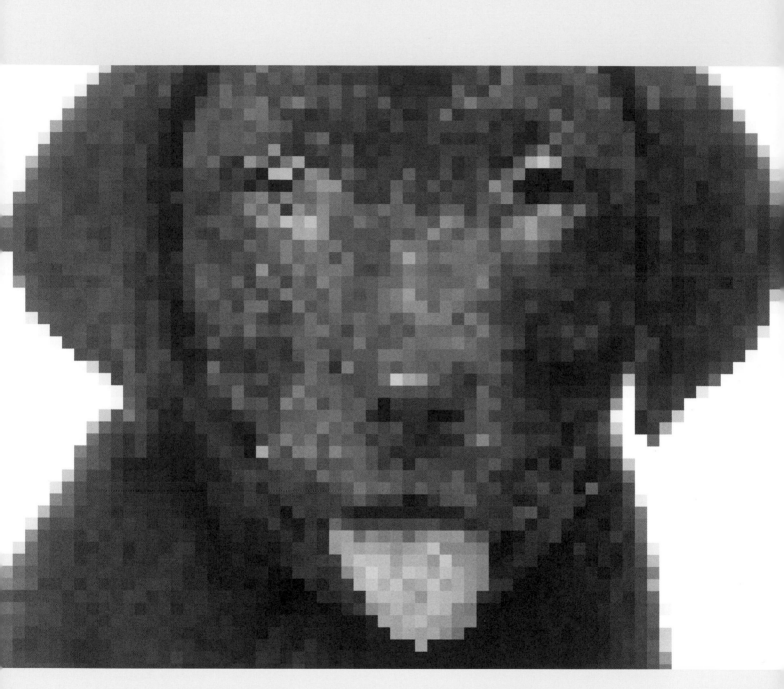

10 DPI : BAD.

The interesting thing about images that have resolution this low is that from far away they still are recognizable. Have a friend hold this page up, and go to the far end of a room or hallway. It will actually be more clear, because your eye compresses the image and fills in the blanks. But the closer you get to it, the more it will break down.

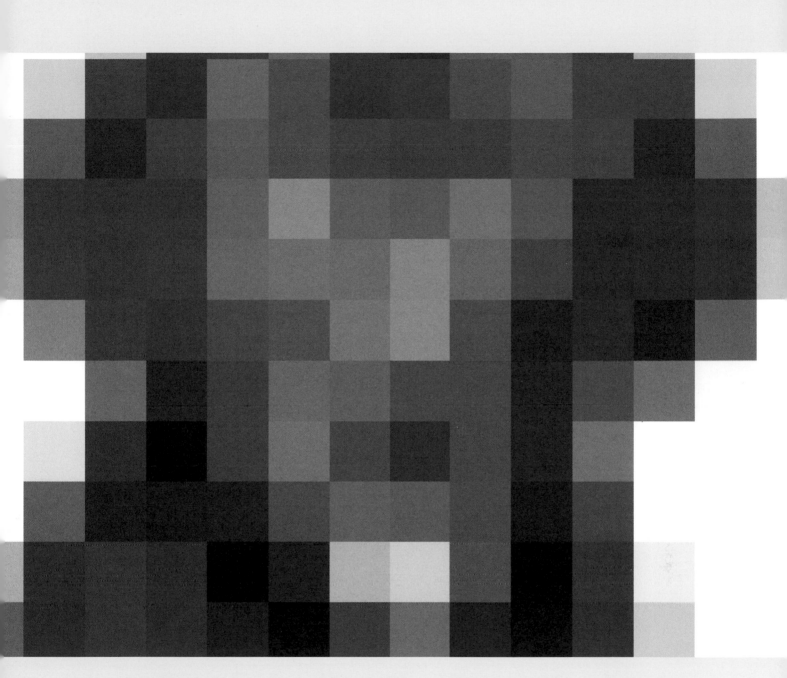

2 DPI:SO BAD THAT NOW IT'S KIND OF COOL.

When it's broken down this much, it just becomes a grid of blocks, which are also called pixels. If you zoom in on any digital image, no matter how high the resolution, you will eventually get to a point where it looks like this.

Image Cropping

Cropping an image means that you are taking a small part of a picture and enlarging it, or otherwise emphasizing it, to get across a certain point. This is also known as taking a detail. It is a very simple and useful design tool, since it forces the viewer to look at something differently.

In *The Wind-Up Bird Chronicle* by Haruki Murakami, the narrator of the story thinks he hears a wind-up bird chirping in the trees in his neighborhood, but he cannot see it. When you see just the front of this book (opposite), it's not clear exactly what you're looking at—it's what's called an abstraction. But when you lay the jacket out flat (below), the entire image becomes clear.

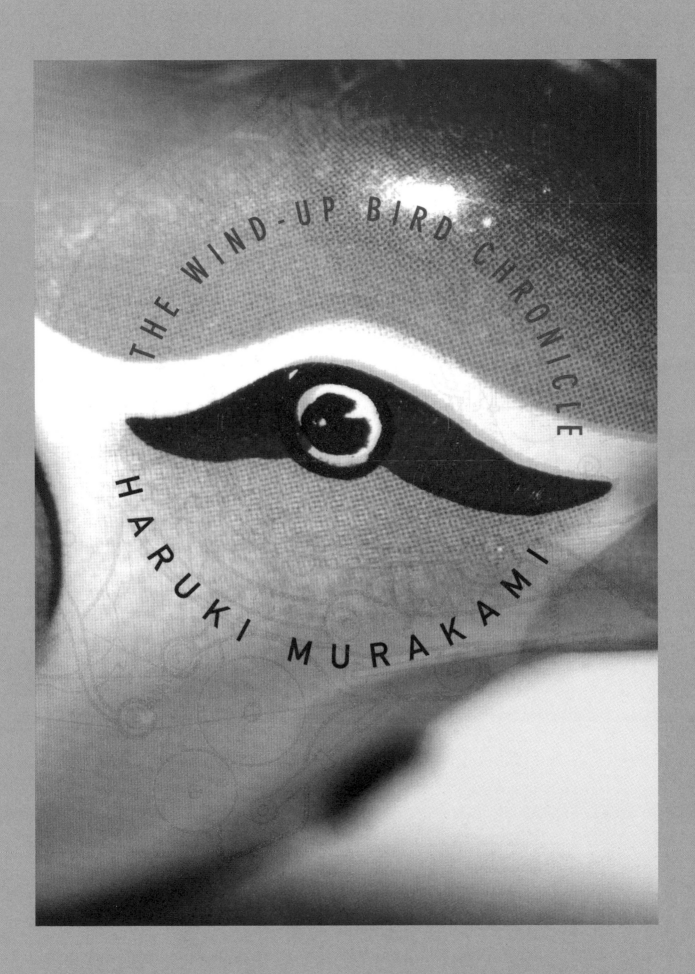

THE WIND-UP BIRD CHRONICLE

HARUKI MURAKAMI

Repetition and Pattern

One of the most effective and easily achieved graphic effects is repetition. Similar to the "big and small" lesson, an image can gain intensified or even completely different meaning when you repeat it on a picture plane. Pop artists of the 1960s—most notably Andy Warhol—latched onto this idea and exploited it with wild success.

The thing about repetition is that once you start using it, then you have to consider pattern. Pattern is the arrangement of the repetition, and it takes some practice and skill to make it interesting.

Let's take these two random elements. What can we do with them?

 + =

Symmetry

You can use repetition and patterning in different ways. When things mirror each other perfectly, as on this page, they are symmetrical.

Asymmetry

When things don't mirror each other, as on this page, they are asymmetrical.

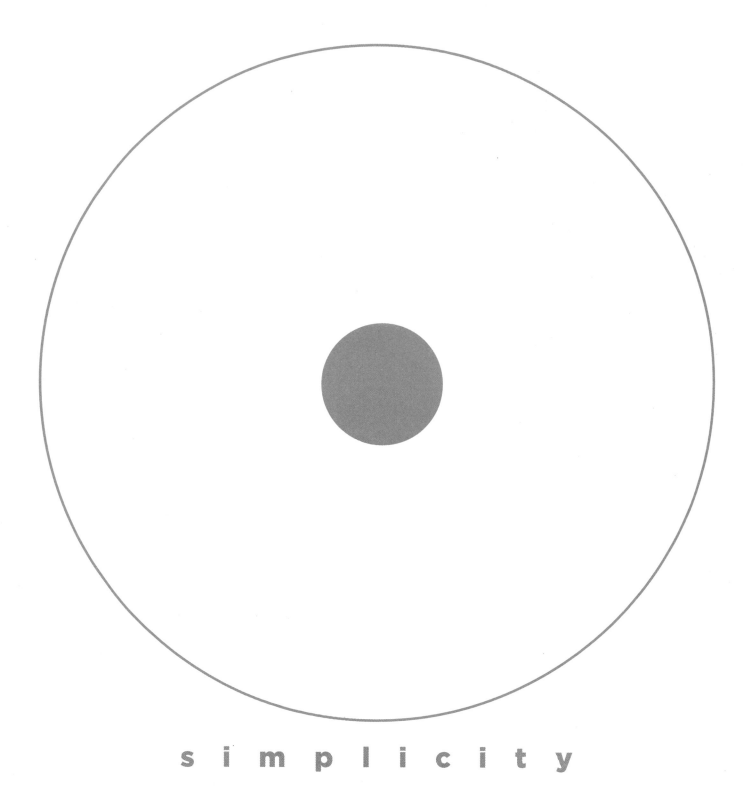

s i m p l i c i t y

Simple, direct visual elements will get the attention of your viewer in a different way than complex images that the receiver will have to decode. This pure, uncomplicated circle form works well for simplicity. It has no edges, no beginning, and no end. Circles symbolize harmony, cycles, balance, calm, focus.

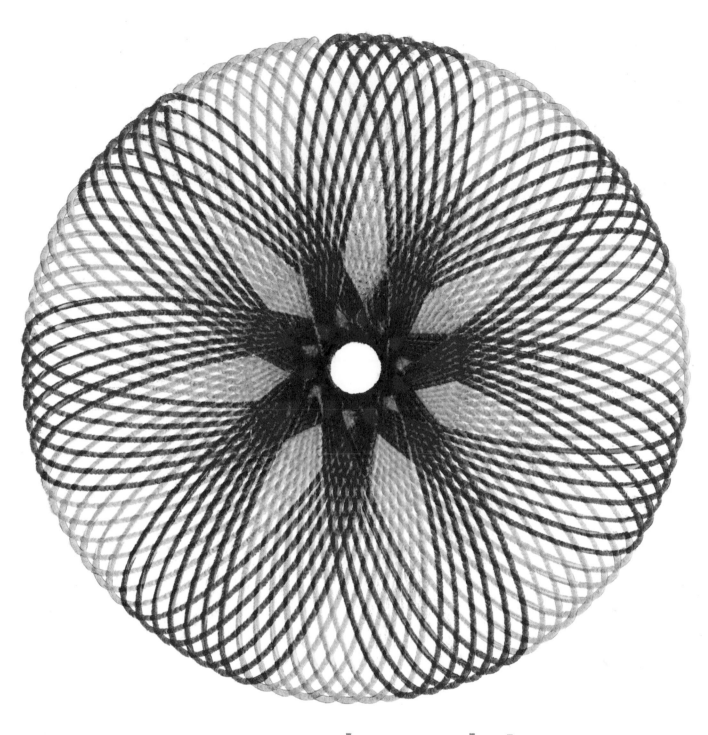

c o m p l e x i t y

Complexity has to be very carefully managed or it becomes chaos. This image was made by hand with different colored ballpoint pens using a plastic device created in 1957 called a Spirograph. Yes, you could make one on your computer, but it wouldn't be nearly as much fun.

COLOR
THEORY

angry

frightened

tranquil

economic

royal

Floridian

WHAT COLOR IS YOUR IDEA?

Colors communicate in ways that words just can't. This is very, very hard to explain, and that's the whole point. You can't describe what "blue" is to, say, a person born blind. The emotional power of color is considerable and can greatly affect the way your design is perceived by the viewer.

Whether black and white are actually colors, well, there is an eternal argument. Some people think black is all colors combined into one and white is the absence of all colors. But some people just as strongly believe it's the other way around. Philosophers and designers remain baffled.

PRIMARY
COLORS

Red, yellow, and blue comprise what's known as the primary colors. This means that all other colors can be made from combinations of just these three, along with or without tints of black and white. I know this seems totally impossible, but somehow it's true. If you mix red with blue, you get purple. If you mix yellow with red, you get orange. If you mix blue with yellow, you get green. Purple, orange, and green are known as . . .

SECONDARY
COLORS

PANTONE®: THE DESIGNER'S COLOR MATCHING SYSTEM.

In 1963 a printer named Lawrence Herbert took on the problem of how to standardize something as subjective as colors so that designers and printers could more effectively communicate with one another. The answer was not just proper names, but, more surprisingly: numbers. What he dubbed "The Pantone Matching System" assigns an official name and/or number to each color (over 1,100 of them at this point) and prints them in a thick book of perforated chips, or swatches, that can be removed and compared to the job in progress. Pantone is used almost universally by print and Web designers alike, and it's an invaluable tool.

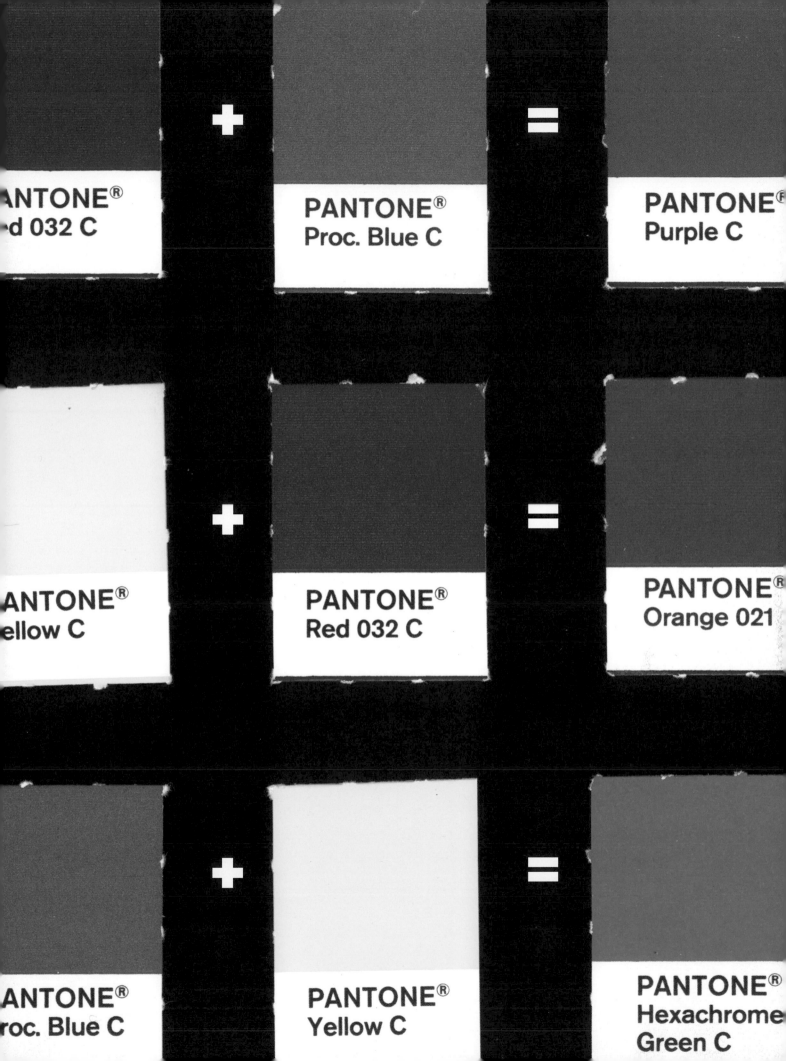

PANTONE®
d 032 C

+

PANTONE®
Proc. Blue C

=

PANTONE®
Purple C

PANTONE®
ellow C

+

PANTONE®
Red 032 C

=

PANTONE®
Orange 021

PANTONE®
roc. Blue C

+

PANTONE®
Yellow C

=

PANTONE®
Hexachrome
Green C

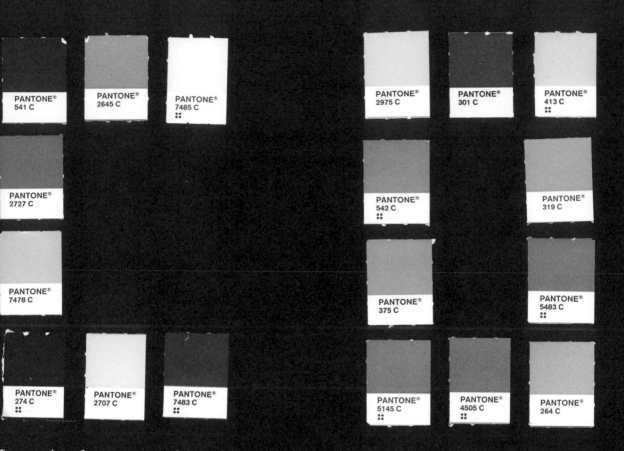

PANTONE® 541 C
PANTONE® 2645 C
PANTONE® 7485 C ::
PANTONE® 2975 C
PANTONE® 301 C
PANTONE® 413 C ::

PANTONE® 2727 C
PANTONE® 542 C ::
PANTONE® 319 C

PANTONE® 7478 C
PANTONE® 375 C
PANTONE® 5483 C ::

PANTONE® 274 C ::
PANTONE® 2707 C
PANTONE® 7483 C ::
PANTONE® 5145 C ::
PANTONE® 4505 C ::
PANTONE® 264 C

Learning how to combine colors to make new ones is key to creating a certain kind of mood in a design. For example, cool colors are made of blues, greens, grays, and purples. They can convey a sense of the chillier side of nature: sky, earth, plants, and, well, low temperatures.

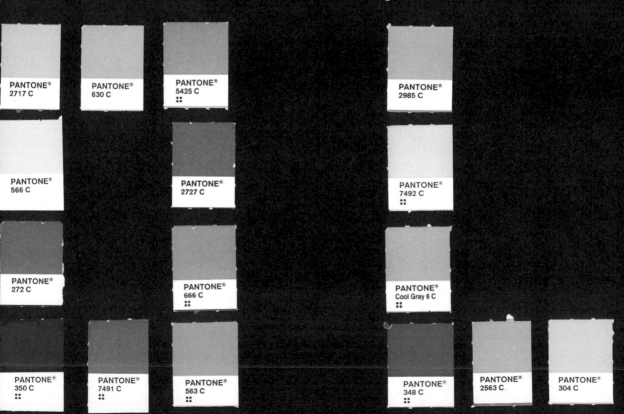

PANTONE® 2717 C
PANTONE® 630 C
PANTONE® 5425 C ::
PANTONE® 2985 C

PANTONE® 566 C
PANTONE® 2727 C
PANTONE® 7492 C ::

PANTONE® 272 C
PANTONE® 666 C ::
PANTONE® Cool Gray 6 C ::

PANTONE® 350 C ::
PANTONE® 7491 C ::
PANTONE® 563 C ::
PANTONE® 348 C
PANTONE® 2563 C .
PANTONE® 304 C

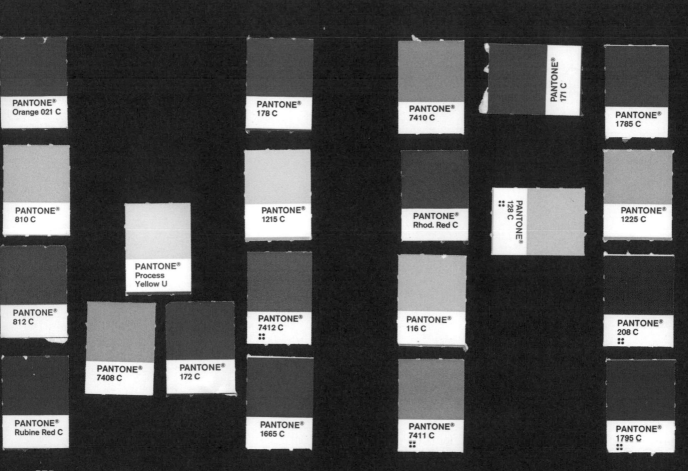

Warm colors—reds, yellows, oranges—are about fiery emotion. They can express both anger and joy, which is kind of amazing. Each of those can be quite hot, actually.

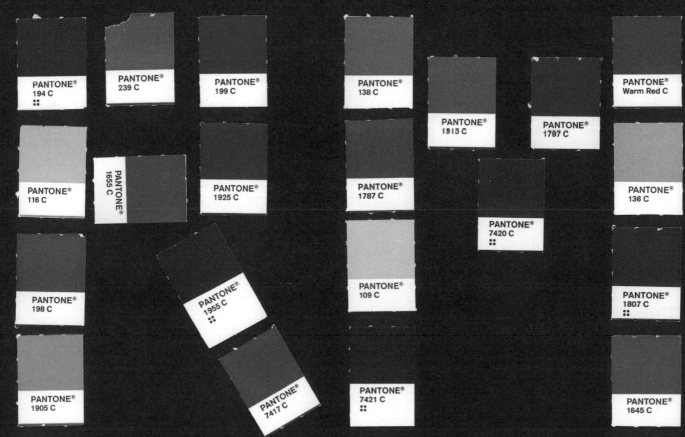

Sometimes less color...

This is especially true when the colors aren't so strong to begin with. For this movie poster I designed, I thought the expression of the woman in the photo was wonderful, but the color palette was a bit drab.

is better.

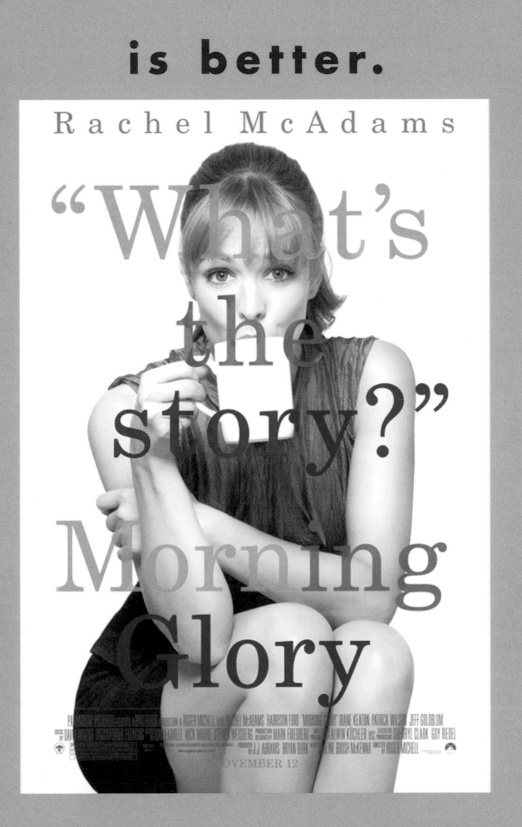

By converting the color picture into a black-and-white photograph, I was able to change the entire palette of the photograph, while also making it possible for me to lay colored title type directly over the photograph.

Abstract

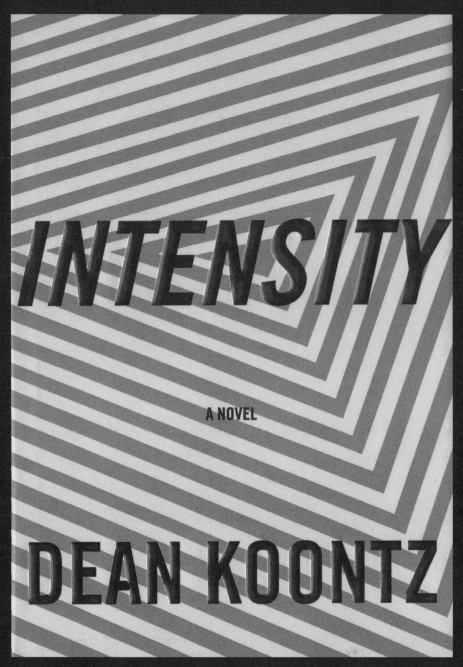

Intensity, by Dean Koontz, is a novel about an extremely troubled person who does very violent things. I did not want to try and show any of these things, but instead decided to make an abstract pattern of colors and shapes to represent his state of mind. Note that the pattern gets bigger, or "intensifies," as it goes from left to right.

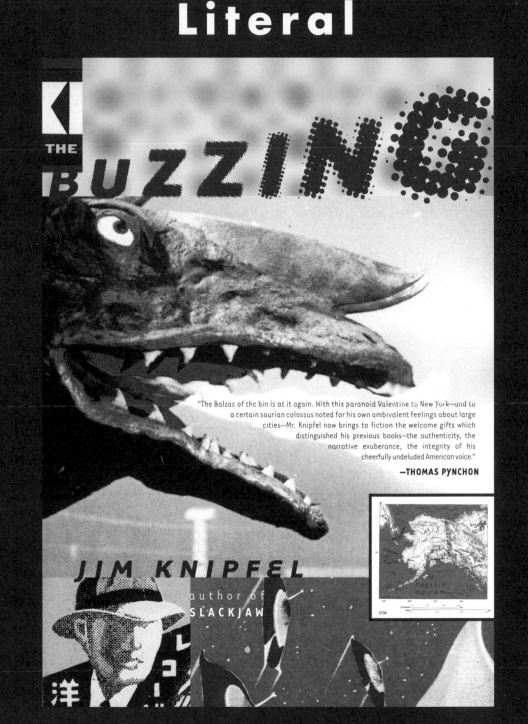

The Buzzing, by Jim Knipfel, is also about troubled people who think all kinds of crazy things are going on (i.e., monsters from outer space, mysterious newspaper reporters, alien invaders, and the State of Alaska, which one of the characters claims has kidnapped him). In this case, I used these literal images on the book cover because they were fun to show.

Positive Space

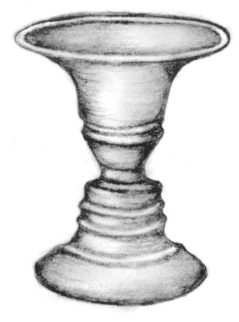

Positive space is that which is taken up by solid objects, and negative space is what surrounds it. One of the most famous examples of how this can work in an interesting way was created by the Danish psychologist Edgar Rubin in 1915. Referred to as Rubin's Vase (above), at first glance it just appears to be, well, a vase. That's the positive space.

THE FEDEX LOGO: A GREAT USE OF NEGATIVE SPACE.

A masterful example of the use of negative space in contemporary graphic design is the current logo for Federal Express (next page), created in 1994 by Lindon Leader while working in the San Francisco office of Landor Associates. He fused two typefaces, Univers 67 and Futura Bold, to create the logo, combining the proportions of the letters so that the middle stroke of the *E* aligned perfectly with the upper left of the *x*. The resulting negative space between the two letters makes a perfect, simple arrow, which is—and this is important—going from left to right. This implies velocity and a clear direction, two qualities that you definitely want in a delivery service.

Negative Space

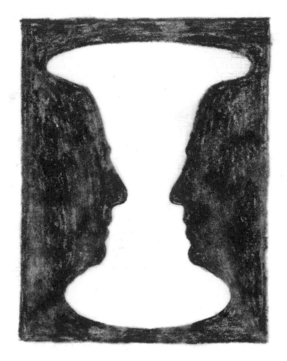

But it's carved in such a way that the negative space on either side of it forms the profiles of two men looking at each other (above). Once you realize this, your perception shifts back and forth between the positive and the negative.

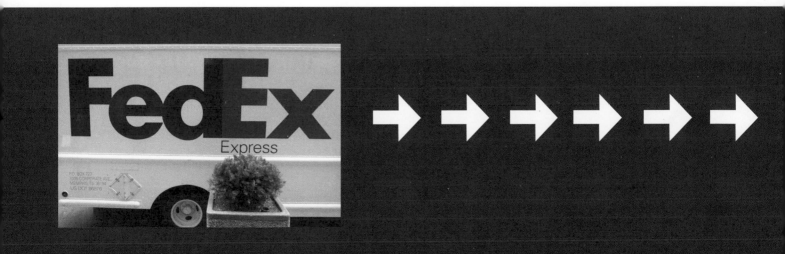

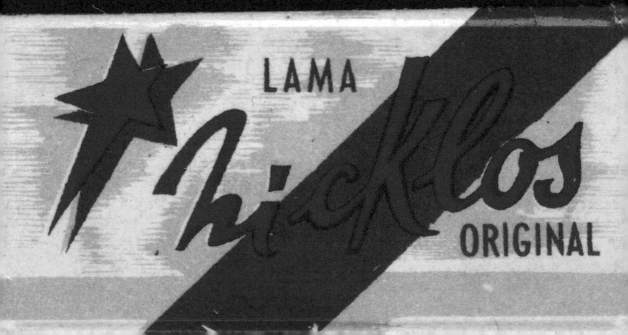

VISUAL VARIATION

This collection of vintage razor blade wrappers from the 1950s shows that many different color schemes and typographic styles can coexist in a way that can please the eye without confusing it. One interesting thing to note is that only a couple of the wrappers actually show the product. This proves that sometimes in advertising beautiful form is enough.

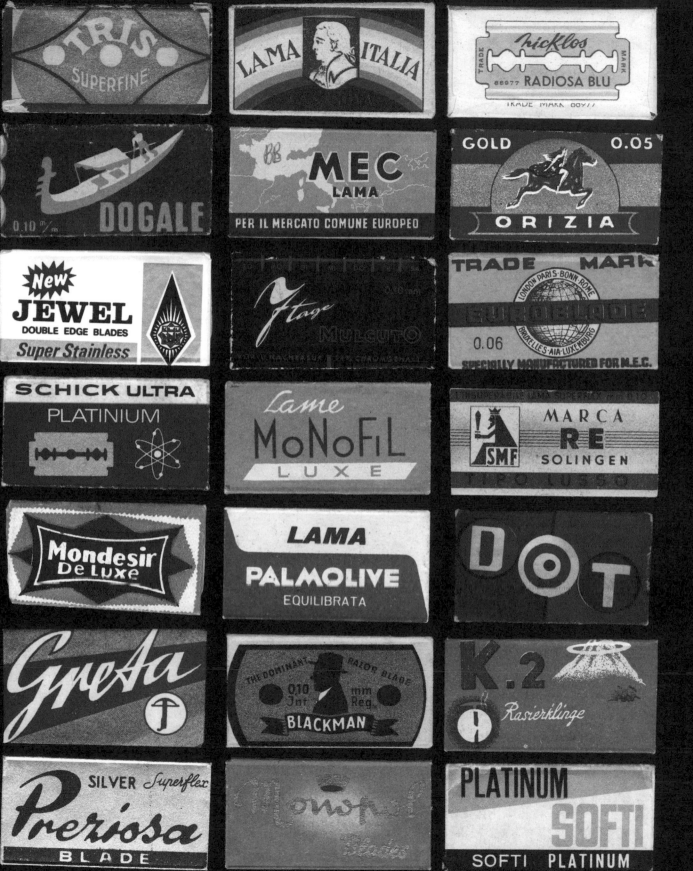

CHAPTER 2

DIDOT HTF 896 BOLD

Ty
ipo

Typography, or lettering, is an essential part of most graphic design (sometimes the only part) and is a truly amazing thing. The fact that you are reading this right now is proof of that. Think about this: The letters of the alphabet, in and of themselves, mean nothing. They are 26 abstract symbols that evolved over time to become what they are today. But, and this is VERY important: When these letters are put into certain combinations, we can conjure, out of nothing, pictures, sounds, tastes, smells, feelings, worlds, entire universes, and place them directly into the reader's head. Yes, you learned this probably in kindergarten or the first grade, but how much have you actually thought about it?

Well, THINK about it.

The exciting thing about letters is that they can take about a zillion different forms—what we call typefaces, or fonts. They can be serif or sans serif (more on that soon). They can be bold or light. They can be italic or script, modern or crazy. They can be futuristic and science fiction–looking, or they can look like something out of the Old West or even ancient times. What letters look like can be just as important as what they say. Part of creating any graphic design using typography has to do with what form that language is going to take. Let's start with your name.

Which font on the following two pages feels like you? ⟶

BULMER SEMIBOLD

HELVETICA NEUE ULTRALIGHT

FLAMA ULTRACONDENSED BOLD

ALBERTUS REGULAR

FUTURA EXTRA BOLD OBLIQUE

GILL SANS LIGHT ITALIC

CENTURY SCHOOLBOOK ITALIC

HUXLEY VERTICAL

CORVINUS SKYLINE

CHAMPION HTF LIGHTWEIGHT

TOKYO TWO

FILOSOFIA UNICASE

P22 BAYER SHADOW

QTYPE SQUARE LIGHT

MESQUITE

SCRIPT MT BOLD

OXIDE STENCIL BOLD

Me

SCRIPTEK ITALIC

TYPEWRITER ELITE REGULAR

Me

DIDOT BOLD

P22 BAYER FONETIK

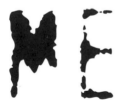

BICKHAM SCRIPT

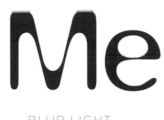

BLUR LIGHT

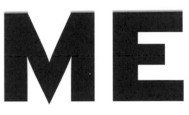

INTERSTATE BLACK

TOTAL DISORDER MIXED

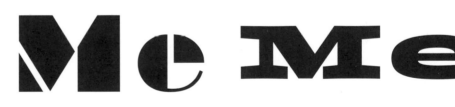

BRAGGADOCIO

ZAPATA BOLD

ME

PRINCETOWN

GIDDYUP

MARKER FAT

BULMER was originally designed by William Martin in 1792 to typeset all of Shakespeare's plays for an edition called the Boydell Shakespeare folio. It's very British.

HELVETICA was created in 1957 by Swiss designer Max Miedinger (see time line, page 17). It is the "sensible shoe" of typefaces, available in many different weights, or thicknesses. This one is on the thin side.

Designed in 2002, FLAMA was intended for signage at first, but then caught on with designers of magazines and newspapers. This condensed and bold version was used in *The Sunday Times* (London) and *Newsweek* magazine.

ALBERTUS was developed by Berthold Wolpe over the period 1932 to 1940 for the Monotype Corporation type foundry. He named the font after Albertus Magnus, the 13th-century German philosopher and theologian. Wolpe studied as a metal engraver, and Albertus was modeled to resemble letters carved into bronze.

FUTURA by German designer Paul Renner was commercially released in 1936, after nine years of development. The original font was based on pure geometric shapes and is one of the most classic sans-serif fonts ever. Even though Futura is considered a landmark of 20th-century modernism, Renner was suspicious of abstract art and disliked many forms of modern culture, such as jazz, movies, and dancing.

GILL SANS is named for Eric Gill, who first drew it in 1926 as signage for a friend's bookstore in Bristol, England. In 1929 the font was commissioned as the official typeface for the London and North Eastern railway, and a version of it became the signage for the London Underground (subway), where you can still see it today.

Morris Fuller Benton produced CENTURY SCHOOLBOOK in 1919 for the American Type Founders at the request of Ginn & Co., a textbook publisher, that was looking for an especially easy-to-read face for textbooks. This is likely the typeface that you first learned to read with.

HUXLEY VERTICAL is a classic of the American Art Deco era, and was designed by Walter Huxley for American Type Founders in 1935. The clean, light strokes and narrow upright characters define its elegant style of the day.

Imre Reiner's CORVINUS was released by the Bauer Type Foundry in 1934. The name of the typeface refers to the Mátyás Corvinus, the king of Hungary during the Renaissance. The word Corvinus is Latin for "little raven," which was Mátyás's family symbol.

Originally developed for *Sports Illustrated* magazine, the CHAMPION GOTHIC series was created by the Hoefler Type Foundry in the 1990s and is based on movable wood type from the turn of the century—the kind that might be used on posters to advertise boxing matches.

Speaking of boxing matches, on March 21, 1988, Mike Tyson successfully defended his world championship title against Tony Tubbs. The poster for the event at the Tokyo Dome was designed by British sensation Neville Brody using a hand-drawn font that would eventually be known as TOKYO.

This is FILOSOFIA, a 1996 reworking of the classic Bodoni serif font by Zuzana Licko, a cofounder of the influential digital type pioneering firm called Emigre. This particular style of the font is called "unicase," as the upper- and lowercase letters occupy the same height.

Inspired by fonts created by Bauhaus master Herbert Bayer, in 1997 Denis and Richard Kegler made P22 BAYER SHADOW, which plays with the idea that you use negative space to create the positive space.

A typeface based on a square, the 2004 FF QTYPE successfully straddles the difficult line between pure geometry and legibility. Achaz Reuss used his years of type design experience to make this versatile multiweight sans-serif font.

MESQUITE is an Adobe Originals typeface designed by Joy Redick for Adobe Systems in 1990, as part of the Adobe Wood Type series. It skillfully mimics the look of old American western "wanted" posters.

SCRIPT MT BOLD was inspired by early-20th-century German commercial hand-lettering. Despite the heaviness of this font from the Monotype company, it has a lively style for packaging and other display purposes.

FF OXIDE STENCIL began Its life during Christian Schwartz's senior year of college, when he worked for a clothing company, designing T-shirts and labels. A lot of stencil type was used, which he digitized and adjusted, making the stencil effect a lot more subtle than usual. The 2005 typeface's final name comes from the chemical composition of rust, since FF Oxide has an unvarnished industrial aesthetic.

British designer David Quay was inspired by the work of the Russian Constructivists and contemporary British designer Neville Brody when he created SCRIPTEK in 1992. This is a strong, geometric slab serif typeface with its angled element in the lowercase.

Before there were computers, there were typewriters. Introduced in the 1860s, they were the first personal keyboard-based machines, featuring two type styles: Pica (10 characters per inch) and Elite (12 per inch). This digitized version of ELITE is from the Monotype company.

Says type designer Jonathan Hoefler: "We designed the DIDOT faces in 1991, as part of the new *Harper's Bazaar* magazine that was being conceptualized by Liz Tilberis and Fabien Baron. We were asked to create a typeface that works like no other, a Modern which— unlike the commercial cuts of Bodoni—would have hairline serifs, and maintain them over a range of sizes."

P22 BAYER FONETIK is another in the family of P22 Bauhaus fonts based on the work of Herbert Bayer (see P22 Bayer Shadow on the opposite page). The name Fonetik is a play on "phonetic," or reading something the way it sounds rather than how it's spelled. Designer Michael Want redrew this in 1997.

Richard Lipton's BICKHAM SCRIPT (developed from 1997 to 2004) is a flowing, formal cursive typeface based on the calligraphy of 18th-century British master-engraver George Bickham. His classic book *The Universal Penman*, from 1733, remains the standard for this art.

In 1992, Neville Brody designed the eroded typeface FF BLUR using a Helvetica font that he put through Adobe Photoshop's "blur" filter three times, thus creating the distressed edges.

INTERSTATE is a digital typeface designed by Tobias Frere-Jones from 1993 to 1994 and licensed by Font Bureau. This font is closely related to a signage alphabet drawn for the United States Federal Highway Administration in 1949.

Designed by Lloyd Springer for Linotype, TOTAL DISORDER is an "acid font," made to look like it's corroding. Perfect for scary stories or depicting the word "filthy" (see page 116).

BRAGGADOCIO is a geometrically constructed sans-serif typeface designed by W. A. Woolley in 1930 for Monotype. The design was based on Futura Black. The word itself means "boastful or arrogant behavior" in Italian.

Dutch designer Erik van Blokland's 1997 FF ZAPATA offers the style of 19th-century western wood and metal types. It's named after a county in Texas, and is ideal for filling pages if you don't have much to say, because it's so wide (as opposed to Mesquite).

Designed by Dick Jones in 1981 for the Linotype company, PRINCETOWN is a quintessential typeface used to represent scholastic activities and athletics. Based on the sturdy slab-serif style featured on varsity letterman sweaters and jackets, it dates all the way back to 1865 at Harvard University, for the baseball team.

In 1993 Laurie Szujewska, Adobe art director, used the rope letters decorating cattle brands and cowboy blankets to create GIDDYUP. "The idea was to make each letter with one line that overlaps like a rope, rather than two strokes joined together," she explains.

Designer Thomas Marecki created MARKER FAT (and Marker Skinny) in 1994 for FontFont as a tribute to urban graffiti. Digital faces that looked like they were drawn by hand, freestyle, became popular during the 1990s, an ironic combination of form and content.

WHO INVENTED THE WRITTEN WORD?

Well, as with most really, really important things, not everyone seems to agree. Especially the experts. But it definitely wasn't just a single person or culture, and we do know that the concept of a written language started more than 3,000 years ago—in more than one place on earth—and that it has evolved ever since. Mankind's tangible record of its daily existence dates back to the cave paintings of the Neolithic Age (Fred Flintstone times), but that's not really what we'd call a language, though in some ways we have come back to it full circle (see Pictogram, page 115). Actually, it is believed that numbers were created first, many thousands of years before letterforms, and were used to keep tallies of possessions like tools and livestock. Records that survive were created by making notches or slashes on materials such as wooden logs, animal bones, and rocks. These slashes eventually became the basis of Roman numerals, which exist to this day—you most commonly see them on grandfather clocks and fancy watches.

CRUDE SLASHES *eventually became* ROMAN NUMERALS.

By around 3000 B.C.,

different civilizations from all over the world started to abandon this system and replace it with a series of symbols that could more easily represent ever larger amounts of things. (Think about it: Would you rather write "1,000" or make a thousand marks on a slate?) Not long after this time (relatively speaking), the Egyptians created a recording system we call hieroglyphics, which used a series of drawings meant to represent real or illusional things, combined with more abstract symbols. Most scholars believe that hieroglyphics was the first real written language. But within a few hundred years, other completely isolated societies in China, Mesopotamia, and Greece were also creating and developing written languages of their own.

As for what we know as the English alphabet, it came from, you guessed it, England. Modern English has its roots in what we call Old English, a blend of dialects used sometime around A.D. 500 by the Anglo-Saxons (German settlers in Great Britain) that was based on Latin (the language spoken in Europe) and Old Norse (the language spoken by the Vikings). Over the centuries, English evolved to become the language that we know today. The written form of English evolved over time, too. English letters are based on the Roman alphabet (700 B.C.) which grew out of the Greek alphabet (800 B.C.), which grew out of the Phoenician alphabet (1050 B.C.). The chart on the opposite page shows you the evolution of the first four letters of the modern English alphabet.

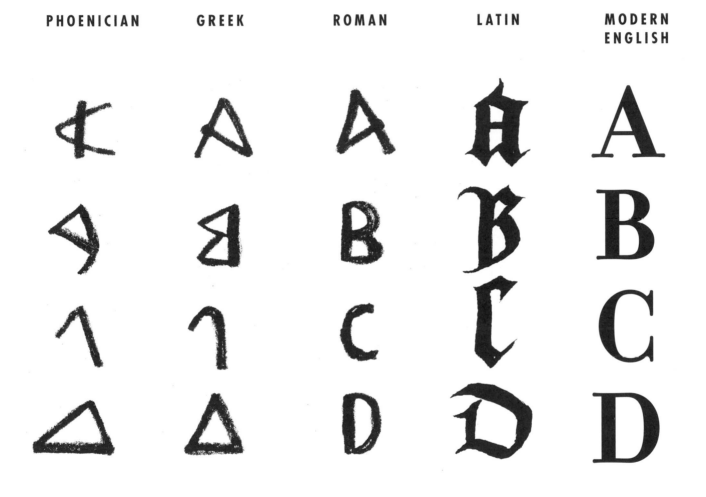

PHOENICIAN GREEK ROMAN LATIN MODERN ENGLISH

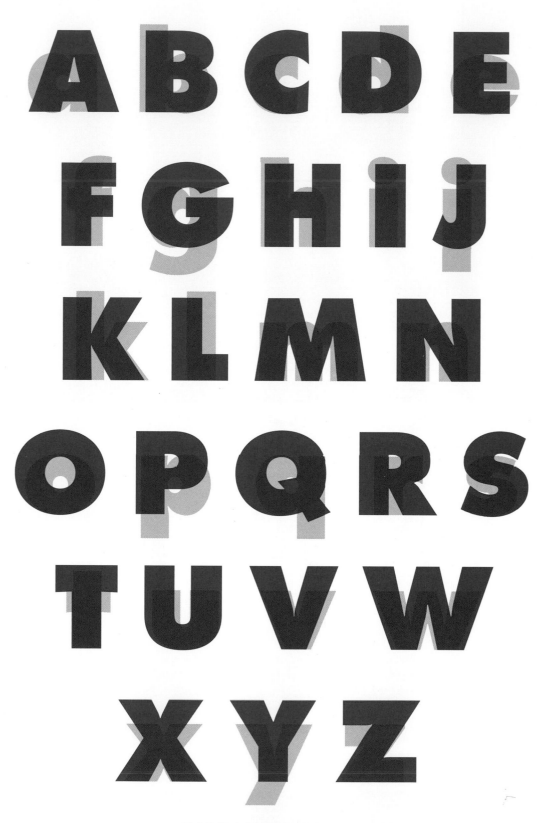

FUTURA EXTRA-BOLD

You should definitely

recognize the alphabet as a miraculous thing, and not take it for granted. These 26 letterforms, or glyphs, can enable you to send any kind of message you want. As a graphic designer, one of the most important things to remember is that the meaning of the word you are setting in type can be affected by the typeface you are using and the way you are using it (see "sincerity" and "irony," pages 116–117).

A typeface is composed of the alphabet letters designed in a way that makes all those letters look like they are part of a family, like they belong together. In this sentence, I am switching from the typeface known as Century Schoolbook to Futura so you can see just how different typefaces can be from one another. Although both Century Schoolbook and Futura represent the same letters of the alphabet, they don't share the same design features. Most typefaces come in a variety of weights and styles, but they still look like they're part of the same family.

The more typefaces you make yourself familiar with, the more fluent a designer you will become (see pages 78–81 for some examples). Typography itself is its own language about language, and the great thing about it is that there's always something new to learn.

SPECIMEN BROADSHEET

This 18th-century sheet shows examples of typefaces. Printers used these specimen charts to decide what fonts to use when printing books and pamphlets and designing posters. Graphic designers use similar charts today.

A SPECIMEN
By WILLIAM CASLON, Letter-Founder, in Chifwell-Street, LONDON.

TYPE STYLES

SERIF

BODONI BOOK

Serifs are the little "feet" at the end of each letter, and can take on many kinds of shapes and styles. Serif type is the most traditional form of contemporary lettering, having evolved from hand-done script, which usually had all the letters connected by thin strokes.

Sans-serif

FUTURA BOLD

Sans is French for "without," so this just means "No serifs." Sans-serif type only came into popular use in the late 19th century, as a bolder way to get your point across, often in advertising.

Italics

FILOSOFIA ITALIC

Italics are slanted letters and can apply to both serif and sans-serif type-faces. They are mainly used for *emphasis* (like that), but can also set a certain block of text apart from the main body copy, such as picture captions.

ALL CAPS

Q TYPE BOLD

The use of all capital letters is usually reserved for titles, headlines, and anything else you want to get more attention. It isn't a great idea to use it for text type. If you send a note and use all caps, IT TENDS TO SEEM LIKE YOU'RE SHOUTING. It's the text equivalent of turning the volume up to 11 all the time. Not recommended.

Upper- and Lowercase

BULMER SEMI-BOLD

Upper- and lowercase type, often referred to as u&lc, is what you're reading right now, and is the usual way in which text is set. The capital after the period helps emphasize that a new sentence is starting and marks the pace for the reader. Capital letters for things that normally wouldn't be capitalized can give them special meaning, as in "Sheila had a bad night's sleep and was in one of Her Moods."

POINTS AND PICAS

The first (and perhaps the most important) component of typography is the size of the font. In typography, the size of the letters is measured in something called "picas," which are divided into "points." There are 12 points to every pica, kind of like there are 12 inches in every foot.

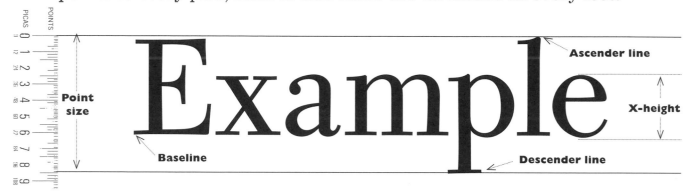

The point size of a font is measured from the top of the ascender line to the bottom of the descender line. If you measure the word "example" above with a pica ruler, you'll see that there are exactly 100 points from the top of the l to the bottom of the p. That means "example" is set in 100 point type.

This is 50 points.

This is 40 points.

This is 30 points.

This is 20 points.

This is 10 points.

KERNING

The space between letters is known as "kerning." For the kerning to look good, it has to be spaced out in a way that makes it readable.

This kerning is too tight.

Letterforms should not touch each other. You want some "air" between them or they are hard to read.

This kerning is standard.

There should be a sense of even spacing between letters. This sometimes has to be adjusted according to the shape of the letter and the style of the font. Notice in the words above that there seems to be a little extra negative space between the k and the e because of the shape of those letters.

This kerning is wide.

Sometimes designers use very wide kerning to convey a sense of elegance. When letters have a very wide kerning, they are said to be "letterspaced."

"Leading" (pronounced "ledd-ing") is the distance, as measured in points, between lines of type. We measure leading from the baseline of one sentence to the baseline of the sentence directly underneath it. It might not seem important when you're dealing with only a couple of lines of text, but once you're dealing with a paragraph, too little leading—or too much—can make that paragraph very difficult to read. See for yourself.

↑

GOOD LEADING
The paragraph above was set 14/23. That means the size of the font
is 14 points and the leading is 23 points.

"Leading" (pronounced "ledd-ing") is the distance, as measured in points, between lines of type. We measure leading from the baseline of one sentence to the baseline of the sentence directly underneath it. It might not seem important when you're dealing with only a couple of lines of text, but once you're dealing with a paragraph, too little leading—or too much—can make that paragraph very difficult to read. See for yourself.

↑

NOT ENOUGH LEADING
This paragraph was set 14/8. That means the size of the font
is 14 points and the leading is 8 points.

WHY IS IT CALLED LEADING?

Back in the days when type used to be set by hand (on a machine called a letterpress), thin strips of lead (the metal) were inserted between the lines of type to increase the vertical space between them. Even in the computer age, the term stuck.

"Leading" (pronounced "ledd-ing") is the distance, as measured in points,

between lines of type. We measure leading from the baseline of one sen-

tence to the baseline of the sentence directly underneath it. It might

not seem important when you're dealing with only a couple of lines of

text, but once you're dealing with a paragraph, too little leading—or too

much—can make that paragraph very difficult to read. See for yourself.

TOO MUCH LEADING
**This paragraph was set 14/71. That means the size of the font
is 14 points and the leading is 71 points.**

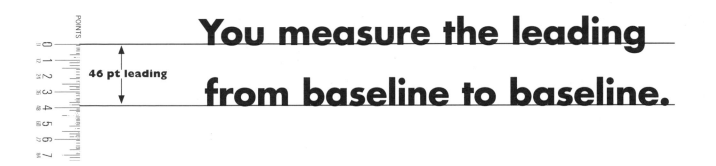

**You measure the leading
from baseline to baseline.**

46 pt leading

Why? Because of the way everything works together on the page—the mix of typefaces, the lines that separate the ads, interspersed by a few solid black panels, the use of symmetry, positive and negative space, patterns, and even some repetition. Beautiful.

GEBRAUCHSGRAPHIK.
THE FIRST GRAPHIC DESIGN MAGAZINE (pronounced "Gee-browsh-gra-feek"). Founded in Berlin in 1923 by H. K. Frenzel, this magazine was extremely influential in presenting new graphic styles from all over Europe to the rest of the world. With text in English as well as German, it was a primary source of inspiration for aspiring graphic designers in America, including a teenager in Brooklyn named Paul Rand (p. 17). After suspending publication during World War II, it started up again in 1950, and continues publication to this day, under the title *Novum*.

CONTENT

THE FUNDAMENTAL QUESTION

FORM FOLLOWS FUNCTION

THE EQUATION

If form is the last thing you consider when making a piece of graphic design, then content is the first. The reason we started in this book with form is that it's much easier to understand, and you've already been considering it since you were born.

Content is harder to figure out, but it's what you start with, and it dictates what form your design will take. Let's try solving a simple but very important design problem: You need to create something that will help people figure out where to leave a certain place, especially if there's some sort of emergency. An EXIT sign. You see these all the time, at school and in public buildings, and there's a reason they look the way they do. But the person who first designed them was faced with a design challenge, which was to create a sign that clearly and easily addressed a question people had whenever they were inside of a place:

"How do I get out of here?"

Here are two very different approaches to solving this problem. The content in both is technically the same, but the forms drastically change its meaning and effectiveness. The sign on this page, one could say, is "pretty" and "elegant," which are not bad things, except that in this case the content doesn't require that at all. The content demands an instant read. As for the colors, they are warm and inviting, but the light blue against the orange isn't that easy to read. In fact, the colors "vibrate" against each other, which means neither one is really standing out against the other. That makes this sign hard to read.

"What?"

The sign on this page is the recognized best solution. You've seen the version that lights up when you go to the movies or the theater. Leaving aside the fact that it's usually illuminated, this really works for three reasons: 1. The typeface is very straightforward, nothing fancy here. Thick slabs that don't vary in width and don't require too much visual processing. 2. It's in red. Red always means "Pay Attention." 3. The background color pushes the typography forward. This also works if the background is white—which it often is—the main point being that it doesn't fight the text for attention.

"Oh!"

The designer of the EXIT sign had a challenge that was dictated by a need, and that is always **the fundamental question** in design:

WHAT ARE YOU TRYING TO COMMUNICATE?

For any given design problem, you have to ask: What is this trying to do? What is the content's purpose?

This purpose is called a function. And once you determine its function, its form—or what it's going to look like— will follow.

Always remember:

"FORM FOLLOWS FUNCTION."

WHO SAID THAT? It was a great American architect named Louis Sullivan, in 1896. The original phrase was "Form ever follows function." He declared this in an article he wrote for *Lippincott's Magazine* called "The Tall Office Building Artistically Considered." Even though he was talking about buildings, this concept can be applied to every design discipline, like industrial design.

The dinner fork dates all the way back to the Roman Empire, centuries after the knife and spoon were on the table. But you can't deny it's an extension of the human hand, and that has a lot to do with the way it's designed.

CONTENT

+

FORM

+

TYPE

=

GRAPHIC

DESIGN

But WAIT! Let's not forget about . . .

CHAPTER 4

LITERAL/SUGGESTIVE • ILLUSION •
METAPHOR • VISUAL FLAVOR •
PHOTOGRAPHY/ILLUSTRATION/CARTOON/PICTOGRAM
• SINCERITY/IRONY

Your concept is your idea of what to do, based on what the problem is. It's the bridge between Content and Form, the means to get from one to the other. Where do ideas come from? How can you create them? This is a very important question, and one that designers ask themselves all the time.

The easy answer is that you let the problem itself give you ideas.

The harder answer is that ideas come from the world all around you, and you have to try and recognize them. An apple falls on Newton's head, and he starts to think about the concept of gravity. Luck often plays a big part in how you generate ideas, but you have to meet it halfway.

On the opposite page is the cover I designed for a book of poems. The title, *Hazmat*, is short for "Hazardous Material," and though this usually refers to combustible things like gasoline, this time the author is applying it to human relationships. While I was trying to figure out the concept for this book cover, I happened to see this amazing photograph by Erica Larson. Something clicked in my head: The doorbell rings, you hear an explosion, and you open it. Poof! What happened?

hazmat

POEMS

J. D. McCLATCHY

LITERAL

This is a novel about someone who writes a novel about a friend of his, who is a total mess. And then the friend reads it. And gets really, really mad. The illustration by Peter Quach conveys the concept really well: The large hand with the pen dwarfs the small blue man underneath it, as if it can crush him. Remember the saying "the pen is mightier than the sword"? Here it is!

SUGGESTIVE

The title of this middle-grade novel by R. J. Palacio refers to Auggie Pullman, a ten-year-old boy who was born with an extreme craniofacial deformity. The challenge was to depict Auggie's face on the cover in a way that wasn't literal, which might put potential readers off. This illustration by Tad Carpenter, as art directed by Kate Gartner, was a brilliant way to suggest a face without actually showing any details. Better to let readers fill in the features using their imaginations.

ILLUSION

All graphic design is illusion, because it's using ink on paper or pixels on a screen to make you think you're seeing something that's not really there. Photographs have been manipulated almost since they first appeared in the 19th century, but it wasn't until computers came along that "creating" a distorted reality became much easier and commonplace. Still, unless there's a strong concept, it's just mere trickery.

MAGICAL THINKING

TRUE STORIES

AUGUSTEN BURROUGHS
the New York Times bestselling author of RUNNING WITH SCISSORS and DRY

AUGUSTEN BURROUGHS

POSSIBLE SIDE EFFECTS

TRUE STORIES

by the *New York Times* bestselling author of RUNNING WITH SCISSORS and DRY

The images used on both of these book covers were created by photographer-illustrator Geoff Spear, based on my concepts inspired by the text. He used a program called Photoshop, which you've probably heard of, to alter shots he made in his studio. On the left, the author's idea of "Magical Thinking," which is that you can manipulate the physical world with your mind, is represented by the stream of water coming out of the glass—not down, as should be, but up, in defiance of everything we know about the laws of gravity. On the right, we goofed on the title by adding a sixth finger to the hand (mine).

AND THEN THERE'S REALITY.

Shortly after *Possible Side Effects* was released, Augusten received an email from a fan in Phoenix, Arizona, who said, "When I saw this cover, I burst into tears, because I realized I was not alone." She included the picture to the right. My thought was, "Where were you when we were making this jacket?"

METAPHOR

A metaphor is something that represents something else. It can be a figure of speech, as when Shakespeare said, "All the world's a stage. And all the men and women merely players." He's not saying that's what the world actually is; he's saying that's what it's like. If Shakespeare were alive today and saying the same thing in a more modern way, it would be more like, "All the world's a reality-TV show. And all of us are being followed around by cameras 24/7." Or maybe not.

Visual metaphors work the same way: You are representing one thing with another thing so you can make a symbolic statement about it. You make your audience think differently about something through substitution. This is called an "analogy."

Take, for example, an apple. It can stand for many things. An apple with a bite out of it represents man's quest for knowledge, referring to the story of the Garden of Eden. So it's not a bad symbol for a computer company. "The Big Apple" has become the unofficial nickname of New York City, implying that it is a huge, bountiful place waiting to be "bitten into." If someone says, "You are the apple of my eye," that means they like you a lot.

On the opposite page is a book cover on which I used a photograph by German photographer Anton Stankowski. The spoon and fork look like two people in a bed, which seemed an interesting way to illustrate the title in a metaphorical way.

ALL YOU WHO SLEEP TONIGHT

POEMS BY · VIKRAM SETH

VISUAL FLAVOR

Sometimes concept is defined by the way in which you choose to interpret something visually. There are many ways to depict a subject, and the choices you make, as a designer, influence the way something is perceived.

The four covers shown here, which I did for Knopf, are all for the same book. We ended up using the one on the top left, which is an all-type cover. The other designs use different visual elements to represent the themes of the book. The one on the bottom left uses a black-and-white photograph, while the one on the right uses a full-color photograph. The one in the middle is very stark. I'm not quite convinced we ended up with the best cover. What do you think?

On the following pages you'll see me represented in four different ways. Each one has its own visual flavor, depending on the medium used: photography, illustration, cartoon, or pictogram. No single image is better than another. They all give off their own vibe about the subject.

photography

Photographs show things as they really are (at least we are led to think so—remember the discussion about illusion on pages 108–109?). This photo of me was taken several years ago by a photographer named John Madere. A picture like this is meant to be very sincere, with nothing to hide, and you use it when you want to be as honest as you can with your audience. I use this to promote my speaking gigs, because it makes me look totally unthreatening. Doesn't it?

illustration

This drawing, by Randy Glass, is a literal "translation" of the photograph to the left, in pen-and-ink on paper. He uses a technique that could be called "stipple," or in other words, lots of dots. It may look simple, but if you try it (and you should), you'll quickly find out that it is really, really hard to do it this well.

What happens in our heads when we go from a photograph to a drawing like this, which is very realistic, but not real? Do we think about the subject in a different way? I used this as an "author photo" on a book of satire I worked on called *True Prep* (see page 43). It is meant to convey an interpretation of reality.

cartoon

The cartoonist Ivan Brunetti used ink and brush to create this portrait that is far simpler than Randy's, using fluid lines and a sense of whimsical mischief, but it's also a bit more complicated. Why? Because it seems to have a point of view, or opinion, about the subject. Cartooning can use exaggerated forms to get a stronger emotional reaction from you. Masters of the craft such as Charles Schulz have shown that making the body disproportionately smaller to the head even gives adults the look and feel of children or infants. Here the arched right eyebrow is also very important, suggesting disbelief and slight irritation.

pictogram

As we've gone from left to right on this spread we also have, in a way, gone back in time, in terms of how mankind has made pictures over many hundreds of years. Though I created this simple image on a computer, it is not all that different from the way a cave painting might have been made in prehistoric times. That is, showing your subject in as direct a way possible, using as few lines or shapes as you need to get your point across, but also making it specific to your subject. Not like a generic emoticon, more like a logo.

SINCERITY

The concept of sincerity in graphic design is easy to understand, just as it is in real life: Things mean exactly what they say they do. There is no mystery, no confusion, no attempt to fool anyone.

Often the first assignment in an Introduction to Typography class is to select a word and make it look exactly like what it says it is. This helps people to start thinking about graphic design and the power of typography to represent ideas. Below are two examples of words that are styled to appear to be what they declare themselves to be.

IRONY

Irony, however, is a bit trickier to understand than sincerity—and that's the whole point of it. It's a bit confusing because it's about opposites: When you use irony, you say one thing but you mean the exact opposite.

The words below are styled to be exactly the opposite of what they mean. When you see them, and then read them, you have to pause a second before the cleverness of the message becomes clear. The designer, in this case me, has just shared a little joke with you, and it made you stop and think.

FILTHY

CLEAN

THE COVER OF THIS BOOK is a great example of irony. The form and the content seem to be at cross-purposes: The form of the design is a STOP sign. But the STOP sign is telling you to do the exact opposite, which is to GO. This is meant to first attract your attention, then to make you want to investigate it and figure it out. And I think that's what all book covers should try to do.

CHAPTER 5

10 Design Projects

1. Start a Graphic Design Collection

2. Color Your World

3. Get Positive (and a Bit Negative)

4. Create a Small Poster

5. Redesign Something That You Love

6. Make Your Own Font Specimen Sheet

7. Create Your Own Visual Identity

8. Mark Your Stuff

9. Design a Logo for a Cause You Believe In

10. Do Your Thing—and Then Post It!

, designer!

Now it's your turn.

Are you ready?

10 DESIGN PROJECTS

The design projects I'm assigning you in the following chapter are meant to be thought-provoking, maybe eye-opening, and hopefully fun. They're not, however, meant to be crafts in any way. There's no "one way" to do these. There are no "right" or "wrong" answers. As such, I can't give you a step-by-step kind of approach because, well, that's just not what design is all about. Design is about how YOU interpret your visual world. So these projects are really about YOU!

I would love to see what you come up with, though, so I invite you to post and share your Design Projects on **gothebook.com**. I have had a really wonderful time in my career as a graphic designer, and what I love most is that I continue to learn new things all the time. The world is full of beautiful design, which can sometimes be found in the most unexpected places. So keep your eyes open.

DESIGN PROJECT #1

Start a Graphic Design Collection

This doesn't have to cost a lot of money, and actually it shouldn't. There are bits of cool graphic design all around you—you just have to recognize them. Ticket stubs, magazine clippings, newspaper ads, candy wrappers, all kinds of packaging that would otherwise get thrown away. Opposite is a page from one of my scrapbooks of labels and advertisements I found when I was visiting Japan. I liked them so much I started gluing them into my scrapbook, just as you see here.

Your first design project is to start a scrapbook of things you find that by themselves might not be so interesting, but can be when you combine them. Remember what you learned about visual variation (page 72) and typographic color (page 90)? Here's your chance to apply all of that. Look for colors and textures that might go well together on a page. Look for typography that you like. Piece shapes together like puzzle pieces to create an interesting pattern. Every page of your scrapbook can be its own world.

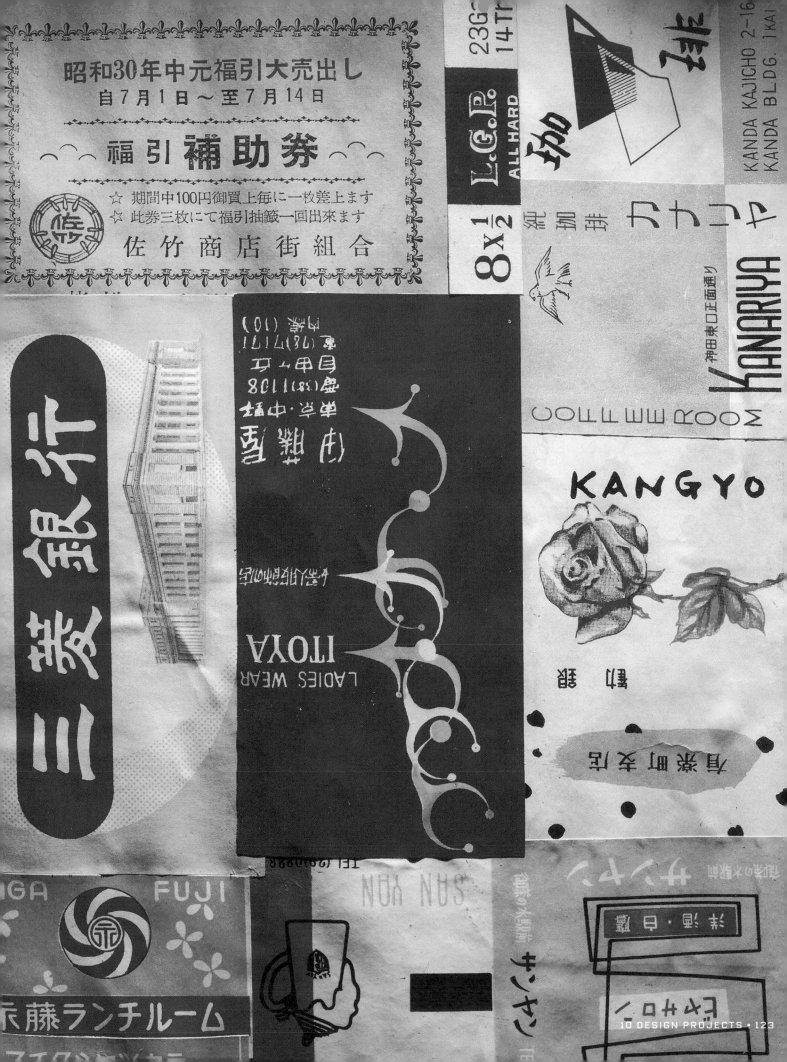

On the opposite page is another page from my scrapbook. This material was collected from a series of design annuals called *27* that I came across recently. Design annuals came into use in the mid-20th century. They were a way to showcase the best designs of the year, kind of like a print version of the Academy Awards. In *27*, twenty-seven designers, illustrators, package designers, and letterers from the Chicago area were asked to present their best efforts for prospective clients. I found much of this fascinating and beautiful—especially since I had never heard of any of these people. It goes to show that there's always something new to learn about the past.

A volume of *27* was published every year until the 1990s, but the examples here are from the 1930s, '40s, '50s, and '60s. I find these old design annuals very inspiring to look at. You can see great work that you can't find anywhere else, and read about the people who made it.

twenty-seven

CHICAGO DESIGNERS

VOLUME 21 / 1960

27

REHBERG

Melrose Crumpet

MAIN COUNSELOR IN DISTRESS AMONG
DA VINCI, RAPHAEL AND REMBRANDT
ANNOUNCES HIS TIE-UP AS IDEA MAN WITH
DOUGLAS RADER
540 NORTH MICHIGAN AVENUE · SUPERIOR 5786

Broadsides · Direct Mail · Typographic Design · Lettering · Layout

EXAMPLES OF POSTER DESIGNS · EFFECTIVE IN ANY SIZE

Presenting

DESIGN IN MERCHANDISING

ROBERT H. ASKREN
605 N. MICHIGAN AVE · SUPERIOR 2844 · CHICAGO

Joe Pearson

Elmer Jacobs

CARL A. ANDERSON / DESIGN

ADVERTISING
DESIGN
POSTERS
LAYOUTS

NORMAN ANDERSEN
1012 N. DEARBORN ST.
DELAWARE 0654

EVERETT McNEAR

DESIGN PROJECT #2

Color Your World

This project is all about color (pages 60–67). Remember primary and secondary colors? Remember how certain colors "vibrate" against other colors (page 98)? Here's your chance to test those theories and decide for yourself what kind of color palettes are most interesting to you.

For this design project, take something that you are always used to seeing a certain color, and make it something else. Like a bunch of bananas—what if you painted them bright fluorescent red? And what would happen if you painted an orange bright blue? That's what I did on the opposite page. Then I placed them on a bright yellow paper and photographed them. I think they're beautiful, but they also change the way I perceive them.

Once you've decided what you're going to "color," you can use spray paint (with adult supervision) or acrylic crafts paint. I only chose two items, but you can decide to do dozens. Then position the items on brightly colored construction paper. Don't forget to post your creations on the website (see page 121)! And hey, it should go without saying, but do NOT eat any of this stuff after it's been painted.

DESIGN PROJECT #3

Get Positive (and a Bit Negative)

This project is all about form (Chapter 1) with a little bit of color theory (pages 60–67) thrown in. Remember positive and negative spaces (page 70–71) and repetition and pattern (pages 54–58)? You'll need scissors and brightly colored construction paper for this.

Take two sheets of the same sized construction paper. They should be different colors. Cut one sheet into six separate rectangles, any size. Then glue the shapes onto the other sheet of construction paper in any way you want. You can overlap the rectangles, or have some not touch at all. The idea is to arrange them on the page so that you really notice the negative space peeking through underneath. It's up to you to decide how much negative space you'll see. You may leave very little, as in the example on the top left on the opposite page, or you may decide to leave a lot of negative space (see bottom right). Or you may decide that even-steven is the way to go (bottom left). Whatever you decide, make sure to post your designs!

DESIGN PROJECT #4

Create a Small Poster

This project is all about scale (pages 32–33) and cropping (pages 52–53). It's easy to do, though you'll need access to a photocopier. A lot of home printers double as color copiers, but if that's not an option, a trip to Staples might be in your future.

Start by finding a piece of graphic design that appeals to you (I'm using this cigar box label on the left). Take a white piece of paper that's the same size as your graphic design, cut a tiny square or rectangle out, and then place the open window over the design to find a new way to crop it. You'll notice details you never noticed before. Enlarge that little portion of the design on the color copier, making it as big as you can. You'll be amazed at how beautiful your new poster is!

CALL AGAIN

J. A. DOLL
CIGAR CO. CALL AGAIN MT. WOLF
PENNA.

DESIGN PROJECT #5

Redesign Something That You Love

Now that you've been learning about what to look for in good graphic design, you'll probably be noticing examples of graphic design that *aren't* so great. Or maybe they're great, but they're not the way YOU would have approached the concept.

That's where this design project comes in. It's all about concept (pages 104–117)—as well as how you choose to execute your concept. Do you have a favorite book but don't like the cover? Is the poster for your favorite movie not at all what you think it could be? Well, go for it! What should it really look like? Here's your chance to redesign a book or poster of something that means a lot to you.

On the opposite page, I tried my hand at an old classic (hint, "Luke, I am your father!"). I used two pictures of actual deep space that I found on-line at the NASA site for the Hubble telescope. They have beautiful hi-res images of actual deep space, and they're for use by the general public. So, I printed them out, cut out the shape of Darth Vader's helmet, and placed it over the other image. I kind of liked the way it suggests a portal to another world. Let's see what you do!

DESIGN PROJECT #6

Make Your Own Font Specimen Sheet

Here's a great way to get your feet wet with typography. All you need is a pair of scissors, a glue stick, and a pile of newspapers or magazines.

Go through the pages of these periodicals and target the letterforms that you find appealing. What type styles are they (pages 86–89)? Are they serif or sans serif? Are they italics, all caps, or upper- and lowercase?

Cut them out and piece them together on an 8½" x 11" sheet of paper to create a font specimen broad sheet (see page 87) of your very own. For extra credit, can you identify any of the fonts? On pages 78–81 (and on the next few pages) you'll find the names of some common fonts that may help with this. You might also think about scavenging around flea markets and old bookstores to see if you could get a hold of typesetting books and font catalogs (see sidebar below).

FONTS ANYONE? Back in the days before computers made it possible for people to set type themselves, designers used to work with typesetters to set type. A designer would look through type catalogs full of thousands of different typefaces, and then spec the copy that needed to be typeset. The main text used throughout *Go*, for instance, would have spec'd like this: "Century Schoolbook, 14/23 x 39, set standard." A typesetter would have known that meant to set the text in 14 point Century Schoolbook, with a 23 point leading, in lines that were 39 picas wide, and that the kerning would be neither tight nor loose.

CASLON REGULAR 26 PT.

ABCDEFGHIJKLMNOPQRSTUVWXYZ
abcdefghijklmnopqrstuvwxyz

DIDOT 26 PT.

ABCDEFGHIJKLMNOPQRSTUVWXYZ
abcdefghijklmnopqrstuvwxyz

FRANKLIN GOTHIC 26 PT.

ABCDEFGHIJKLMNOPQRSTUVWXYZ
abcdefghijklmnopqrstuvwxyz

FUTURA MEDIUM 26 PT.

ABCDEFGHIJKLMNOPQRSTUVWXYZ
abcdefghijklmnopqrstuvwxyz

GARAMOND REGULAR 26 PT.

ABCDEFGHIJKLMNOPQRSTUVWXYZ
abcdefghijklmnopqrstuvwxyz

HELVETICA 26 PT.

ABCDEFGHIJKLMNOPQRSTUVWXYZ
abcdefghijklmnopqrstuvwxyz

NEWS GOTHIC 26 PT.

ABCDEFGHIJKLMNOPQRSTUVWXYZ
abcdefghijklmnopqrstuvwxyz

NOTEPAD 25 PT.

ABCDEFGHIJKLMNOPQRSTUVWXYZ
abcdefghijklmnopqrstuvwxyz

OCRA 25 PT.

ABCDEFGHIJKLMNOPQRSTUVWXYZ
abcdefghijklmnopqrstuvwxyz

PLAYBILL 25 PT.

ABCDEFGHIJKLMNOPQRSTUVWXYZ
abcdefghijklmnopqrstuvwxyz

POPLAR 25 PT.

ABCDEFGHIJKLMNOPQRSTUVWXYZ
abcdefghijklmnopqrstuvwxyz

TIMES 25 PT.

ABCDEFGHIJKLMNOPQRSTUVWXYZ
abcdefghijklmnopqrstuvwxyz

TYPEWRITER 25 PT.

ABCDEFGHIJKLMNOPQRSTUVWXYZ
abcdefghijklmnopqrstuvwxyz

HOW TO IDENTIFY A FONT

First, start with the basics: Is it serif or sans-serif? Look closely at the lettershapes. Notice the difference between key letters, like Rs and Ks and Qs. Look how the capital "C" in some serif alphabets—Didot, for instance—has a serif on both the top and bottom of the letter. The cap "C" in Times has a serif only on the top of the letter. There's a great deal of variation in the way the letters of the alphabet are represented by different fonts, so you have to look really hard to appreciate the subtle and not-so-subtle differences. It takes some practice, but once you get it, you'll never look at typefaces and fonts the same way again!

DESIGN PROJECT #7

Create Your Own
Visual Identity

We all create our own identity, who we are, whether we realize it or not. You're probably doing it already. What you chose to wear this morning. What bag you decided to carry your things in. Any other number of visual components were choices you made about how to realize, or express, your identity. So you've been creating your own identity all along—and you didn't even know it!

In this project, I want you to create a logo for yourself. Of course, before you can begin, there are two things you need to ask yourself:

WHAT IS YOUR IDEA
OF YOURSELF?

AND WHAT IDEA OF YOU DO
YOU WANT OTHERS TO HAVE?

These are both very good questions. And the answers can be quite subjective, which is okay, because this is all about YOU! It's not about what other people think of you, it's how you want to represent yourself to other people. You have to think of a way to represent yourself that is both true to you and also original.

This doesn't have to be as hard as it sounds, because you know yourself better than anyone else, and that means you know what makes you YOU. And you are not like anyone else.

YOU ARE THE CONTENT.

Remember what you learned in Chapter 3? You have to think about WHAT you're trying to accomplish. In this project, you're trying to find a way to visually express yourself, so you're figuring out who you are. Brainstorm a bit. Write a whole bunch of adjectives on a page that you think describe you. Pull out some typefaces that you like from magazines. Take some snapshots of ads and posters that appeal to you when you're out for a walk. And hey, why not put some photos of yourself down on that piece of paper, too? Then, after you've spent a little time brainstorming about WHO you want to be . . .

USE THESE VISUAL ELEMENTS TO GIVE YOURSELF FORM AND TURN IT INTO A LOGO . . .

OH! BUT WHAT EXACTLY IS A LOGO?

It's a visual symbol used by an organization, business, or person so that they can be represented and recognized in a unique way. It's not generally expected that normal kids create logos for themselves, which I think is one of the pretty great reasons for you to do it.

EXAMPLE #1: LOUISE

Let's say there's a girl named Louise. Louise likes to Rollerblade. A lot. So she's going to use that part of her life to create her visual identity. She starts to think about concepts, and quickly recognizes that the initial of her first name sort of looks like a foot (1). She tries the Futura Bold typeface first, because she's a pretty bold girl. Then she adds some wheels to it (2). Not actual drawings of wheels, but circles that suggest the idea of them. So far so good, but then Louise thinks about it some more, and realizes that Rollerblading is about speed, and she has a

(1) (2) (3)

revelation, and it's a big one: This symbol for herself is not literally about Roller-blading, it's about moving forward. That kind of thinking is what makes Louise a graphic designer, and not just your average kid who wants a logo. So, she italicizes (slants) the whole thing to suggest the illusion of moving from left to right (3). Much better.

So, she leaves it at that, straps on her in-line skates, and goes for a session in the park to think some more. When she gets back home and is taking off her skates, she just can't deny that her ankles and feet are actually rather elegant and dainty, and that Futura Bold kind of makes her look like Frankenstein's monster, so she looks at more typefaces and comes upon Didot Bold Italic (4). This makes a lot more sense. As for color, her favorite socks are aquamarine, and the wheels on her skates are bright red, and they look great together (5). Done!

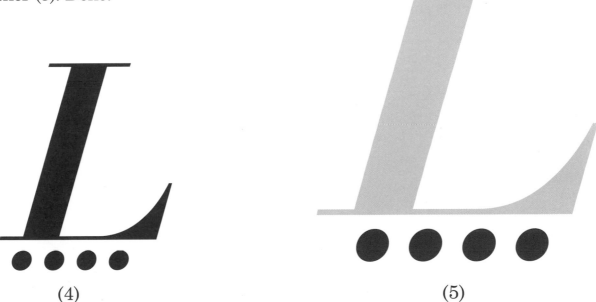

(4) (5)

EXAMPLE #2: BERTRAND

Bertrand loves to DJ at parties for his friends, and he wants to create a symbol for himself to use at his DJ table. He knows that what he does is called "spinning," and he knows why, though he doesn't use vinyl records. Nevertheless, he starts with a *B*, and puts it in Photoshop to start making it spin. But he realizes that when he first tries this, it looks awkward. When he increases it, it gets more interesting, but also more abstract. Then he decides that's okay, because what matters is that it looks good, and it's like a code: He can reveal the meaning to whomever he wants.

Bertrand's world is revolving even though the music doesn't anymore.

After Bertrand designs his logo in Photoshop, he realizes that the form he's created is kind of like a double spiral—something he could actually try to draw by hand with a pencil. It might not be quite as neat, but there's something really cool about the way it looks on a page when it's drawn by hand. He knows he'll be using this hand-drawn logo in lots of different ways, and the variation of the line width and the pencil strokes will actually make the hand-drawn logo more interesting than the computer-rendered version.

A WORD ABOUT HAND-DRAWN TYPE Making lettering by hand is an art in itself, and definitely one worth exploring to learn more about how letterforms are made. You can start by selecting some of your favorite typefaces and enlarging them; then, using a piece of tracing paper and a pencil or pen, practice going over each one to get a feel for proportion, curves, and angles.

GEEK LOVE

I sketched out the type above (for the cover of a novel about circus freaks) on illustration board then finished it with a ruling pen. This was in the days before computers. (Yes, there really was a time before computers!)

At right is an example of hand-done script—or calligraphy*—by cartoonist and designer Chris Ware, using a brush. Lettering like this takes a lot of practice.

the Learners

* The Greek term for "beautiful writing."

DESIGN PROJECT #8

Mark Your Stuff

Now that you've created a visual identity for yourself, think about how you can use it. You can do all kinds of fun things with a logo, from personalizing your own stationery to branding your own backpack. You can also use your logo to create a pattern (pages 54–57) and make your own special style of wrapping paper. Individualize your textbooks by creating unique protective covers for them. It's easy to do.

Remember Bertrand's hand-drawn logo? On the opposite page, you'll see it's been drawn over and over again in pencil on a piece of paper, which creates a pattern, and all the spirals have been colored with crayons (1). Next, Bertrand begins experimenting a little with a photocopier. A photocopier is an incredible tool, by the way—one that designers began using before there were computers. Bertrand makes four copies of the pattern, but at 50 percent of the original size (2), and then he tapes those smaller patterns together (3). But he decides the pattern should be even smaller, so he photocopies the new pattern at 50 percent, tapes those images together, and photocopies the result (4). Now he finally has what he wants, so he glues the photocopy onto a spiral notebook to create a one-of-a-kind piece (5). Now, *that's* marking your stuff.

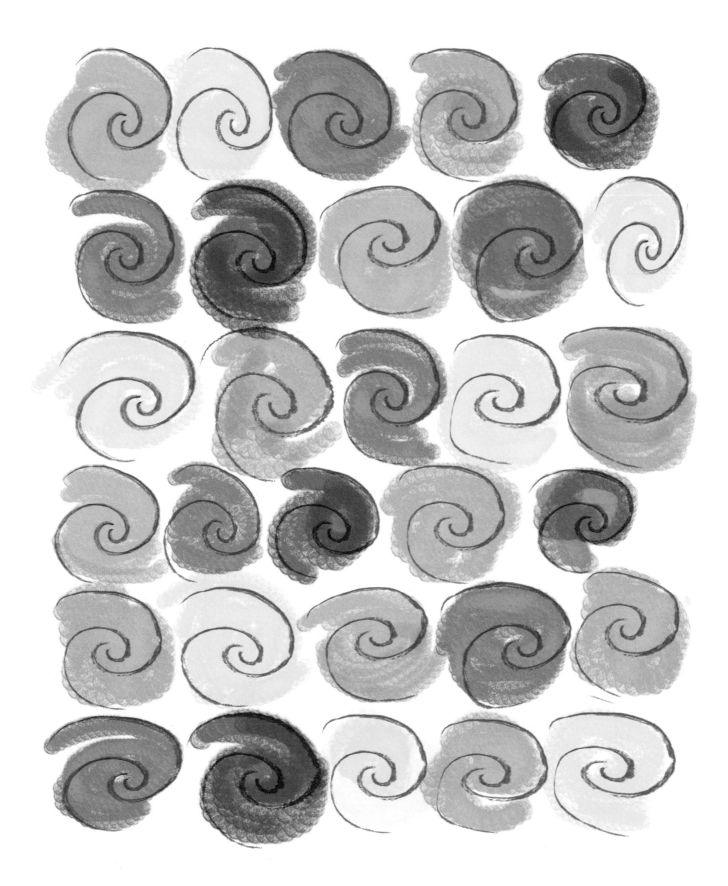

(1)

(2)

(3)

(4)

(5)

DESIGN PROJECT #9

Design a Logo for a Cause You Believe In

One of the most important things about graphic design is that it's like air, food, water, and clothing: Everyone needs it. But like these things, not everyone can afford the best, or even anything close. And if you're just starting out, an excellent way to learn by doing is to help a person, cause, or organization that means something to you by creating graphic design that they can use, whether it's posters, logos, or flyers.

This is how a lot of great designers got started, and there are a zillion ways to do it. One of the most obvious is to begin with a group that you are involved with, whether it's a sports team, a band, a local youth group, or any kind of club. They probably need a logo, and if they already have one, maybe it needs to be redesigned. Or, it needs to be applied to all sorts of things to get the group's message across. You've already had a little practice at creating a logo and marking your stuff: Now it's time to put what you learned to practical use.

The logo on the next page is one of the greatest examples of this, ever. It was created by a brilliant graphic designer named Milton Glaser, in 1977. At that time, New York City was in terrible financial trouble, so the state decided to create an ad campaign to promote tourism. Glaser created

this symbol for officials to use any way they wanted, and he did it pro bono*, because he is a nice guy and loves NYC. And it was very, very successful, and helped save New York, and it was ripped off by everyone and appears all over the world, and probably even on planets we don't know about yet.

Below is a logo that I created for International Peace Day several years ago (also pro bono), and I regret to admit that it wasn't nearly as successful, to say the least. But these kinds of things are definitely worth doing, and every great graphic designer I know contributes to society this way.

*Latin term meaning "For no money at all!"

DESIGN PROJECT #10

Do Your Thing—and Then Post It!

Define it. Answer it. Solve it. Form it. Create it. SEND IT.

So now it's your turn. For your last design project, YOU create a challenge, and YOU come up with the solution. Then, send it to me. But not just this one: ALL of them. Post all your design projects online for the whole world to see! Share your ideas and start talking about graphic design with friends. Get others to notice STUFF! It's all about seeing. Remember, everyone's a graphic designer—even if they don't know it yet. Now you can show them the way.

gothebook.com